54:10

54:10

A Woman's Honest Talk with God about His Unshakable Love

"I will always love you"
~God

Jada McClintick

ELM HILL

A Division of
HarperCollins Christian Publishing

www.elmhillbooks.com

54:10
A Woman's Honest Talk with God about His
Unshakable Love

Published in Nashville, Tennessee, by Elm Hill, an imprint of Thomas Nelson. Elm Hill and Thomas Nelson are registered trademarks of HarperCollins Christian Publishing, Inc.

Elm Hill titles may be purchased in bulk for educational, business, fund-raising, or sales promotional use. For information, please e-mail SpecialMarkets@ ThomasNelson.com.

Scripture quotations marked AMP are from the Amplified˙ Bible. Copyright © 1954, 1958, 1962, 1964, 1965, 1987 by The Lockman Foundation. Used by permission. (www. Lockman.org)

Scripture quotations marked GNT are from the Good News Translation in Today's English Version—Second Edition. Copyright 1992 by American Bible Society. Used by permission.

Scripture quotations marked NCV are from the New Century Version˙. © 2005 by Thomas Nelson. Used by permission. All rights reserved.

Scripture quotations marked NIV are from the Holy Bible, New International Version˙, NIV˙. Copyright © 1973, 1978, 1984, 2011 by Biblica, Inc.˙ Used by permission of Zondervan. All rights reserved worldwide. www.Zondervan.com. The "NIV" and "New International Version" are trademarks registered in the United States Patent and Trademark Office by Biblica, Inc.˙

Scripture quotations marked THE MESSAGE are from *The Message*. Copyright © by Eugene H. Peterson 1993, 1994, 1995, 1996, 2000, 2001, 2002. Used by permission of NavPress. All rights reserved. Represented by Tyndale House Publishers, Inc.

Scripture quotations marked TLB are from The Living Bible. Copyright © 1971. Used by permission of Tyndale House Publishers, Inc., Carol Stream, Illinois 60188. All rights reserved.

Library of Congress Cataloging-in-Publication Data

Library of Congress Control Number: 2019915140

ISBN 978-1-400328635 (Paperback)
ISBN 978-1-400328642 (Hardbound)
ISBN 978-1-400328659 (eBook)

"My Dear Girl,
No matter what,
I will always love you!"
~GOD
Isaiah 54:10

"Though the mountains be shaken, and the hills be removed, yet my unfailing love for you will not be shaken nor my covenant of peace be removed," says the Lord who has compassion on you.
(NIV)

"For even if the mountains walk away and the hills fall to pieces, my love won't walk away from you, my covenant commitment of peace won't fall apart." The God who has compassion on you says so.
(THE MESSAGE)

"For the mountains may depart and the hills disappear, but my kindness shall not leave you. My promise of peace for you will never be broken," says the Lord who has mercy upon you.
(TLB)

"The mountains and hills may crumble, but my love for you will never end; I will keep forever my promise of peace," so says the Lord who loves you.
(GNT)

CONTENTS

"Experience is an author's most valuable asset; experience is the thing that puts the muscle and the breath and the warm blood into the book he writes."

—Mark Twain

INTRODUCTION

When I started writing the words found in this book, I found myself with a collection of short essays about some of the experiences from my life. Some were vulnerable, some were funny and silly, and some were downright heart-wrenching. And none of them were *ever* going to be seen by another pair of human eyes. Or so I thought—God had other plans.

As I looked at the stories collectively, I started to see that there was a thread woven amongst all of them. Love. Not just plain old love, either, but a *no-matter-how-dumb-you-were-I-still-love-you* kind of love. An *even-if-you-eat-crackers-in-bed-I'll-still-love-you* kind of love. An *even-if-you-are-a-bratty-self-absorbed-type-A-control-freak-I'll-still-love you* kind of love.

A mountain-shaking, hill-removing, never-ending, unshakable Isaiah 54:10 kind of love.

I read and reread these stories, reminiscing on the experiences that had prompted me to put them on paper in the first place, and as I was reading them and reflecting on them I realized that I was having a dialogue with my Heavenly Father. We were discussing back and forth why I had made certain choices, how he had always turned it around and used it for good, and how thankful I was that I came out on the other side of whatever it was and learned from it. And always God's love for me was evident in these conversations. He let me know that he had hurt when I

hurt and had cried when I cried. And in that moment it dawned on me that these paragraphs weren't what it was all about. These life experiences, although relatable to some, were not what people needed to hear.

The *real* stories here were the conversations I had with God *about* them.

As you sit and chat over coffee with your closest girlfriend, you learn more and more about her and your relationship becomes stronger and stronger. You share your triumphs, and your screwups, your joys, and your disappointments. She laughs with you, encourages you, and looks deep into your eyes with understanding when you are so sorrowful that you have no words left, only deep pools in your tear-filled eyes. You run to your best friend when you have exciting news to share. And you slap your hand to your forehead as you relate to her how you cannot believe you could possibly have been such a complete and utter idiot…again. And she listens to you over and over and shares with you her thoughts and feelings about all of it.

Talking with God about my experiences and stories has been no different. He has been my confidante and my best friend. He has laughed with me, rejoiced with me, and collected my tears in a bottle. He has both picked me up and let me fall when I insisted that my way was best. I could simply tell you my stories, both silly and sad, and explain how God worked in and through each situation. Or I could share with you the discussions that God and I have had about my experiences and maybe you'll see yourself in these conversations and begin to hear the dialogue that God is having with you as well.

He wants to tell you directly how much he loves you, no matter what.

He wants to remember things with you and tell you exactly why things all went down the way they did. He wants to tell you about how he hurt with you when your world was seemingly crashing down around you, and that you may have felt alone, but you weren't, because he knelt down on the floor beside you, with his face close to the floor and he heard every anguished, whispered cry you made. He wants to tell you about

how his face beamed with pride and his heart nearly burst with happiness when you accomplished that thing you worked so hard for.

Above all else he wants a relationship with you.

He wants to tell you in so many unimaginable ways (far more than I can make words for here), how much he loves you, no matter how many mountains are shaken. That no matter what *he* is never shaken. Not by you. Not by anything you did. Not by what anyone did to you. Not by your broken heart. Not by your unemployment. Not by your failures. Not by that big mistake you made. Not by the death of that person that nearly broke you. Not by your divorce. Not by the abuse that you suffered. Not by your neediness. Not by your insecurities. Not by your anxiety. Not by your emotions. Doesn't matter—not shaken. His love never left you and it never will.

He will always love you…period.

My hope is that some of my experiences, but mostly the talks I have had with God, resonate with you. That *my* conversations become *your* conversations and you feel him talking *directly* to you and you begin to fully understand that he is alive and real and available to talk to you today, tonight, tomorrow, forever.

I pray that this book has landed in your hands at exactly the right time and season in your life. I pray that Isaiah 54:10 pierces your heart and you hear God saying to you, "I will always love you, no matter what."

—Jada

I Am Not a Circus Performer

I have this thing about me where I don't like to mess up. I like to be good at whatever I do.

Scratch that.

I like to be *perfect* at whatever I do, which I know is impossible for anyone outside of Jesus himself, so instead I sing songs with lyrics about perfection being my enemy. I read books about breaking up with perfectionism and being a perfectly imperfect mess and how moxie is a good thing, and I try to embrace the imperfections that make me uniquely designed.

In other words I try to give myself grace…sort of.

I can cut myself some slack with certain minor things, like the areas where we mess up daily. Like the times when we have a crap day, but we pick ourselves back up, brush off our un-Christian behavior, and forge on vowing to do better. I need grace daily, and I'm pretty good at accepting it from my Father, and even giving it away to others…mostly. Perfection is my enemy, remember?

But what about the big stuff?

I have made some life-changing mistakes in my time here on earth, and because of the damage and hurt that I have caused myself and others, I live in fear of messing up in a *big* way. And here's the kicker: as much as you try to walk the straight and narrow, it often happens anyway. We mess up in a go-big-or-go-home kind of way. And then what do we do?

We get intentional.

I have found, post screwup, that when I take the time and intentionally seek God in my *big* situations, he doesn't leave me there. He gives me the grace to move past my life-altering screwups and fully accept his forgiveness and love for me even in my messes. When I spend time with God and get to know his character, I begin to grasp how far, how deep, and how wide his love remains despite my sinful behavior. I've walked through some big things with God. Things that were messy and dark, and seemingly unforgivable and irredeemable. To this day I can still visualize myself deep in a dirty pit of sin. But now on this side of his love I understand that he was right there with me, keeping the worst that could have happened at bay, and watching me with pleading eyes, just waiting for me to reach up my hand to him so he could pull me out and make me clean again.

After I walked through all this yuck and came out brighter and full of joy on the other side, my relationship with Jesus was deeper than ever before.

Then what?

For me this was an intense personal journey I took with my Heavenly Father.

So…what did I do with that valuable experience?

I stuck it under a barrel and there it sat. God gave me light and breathed life back into my dark and ugly low places. Rather than shine that light out into the world and possibly help someone else suffering in like fashion, I covered up that light and tried to keep it secret. I was ashamed.

During my first marriage I suffered as both the victim and the perpetrator of adultery. I warned you it was an ugly place. When I say that I suffered, and that I was not solely the victim, let me take a moment to clarify something. Yes, the adulterer does suffer as well as the person who was betrayed.

(Note: if you are not acquainted with David, a man after God's

own heart, you should be; he's rad. He is also a guy who suffered in his screwups.)

Now before you begin to put on your judgey face, I will kindly ask you to come down off that high horse named self-righteous and stick with me here. I can personally attest to the fact that a fall from the tallest tower of self-righteousness will leave you with a bruised ego to accompany your battered body, broken bones, and broken heart. But that's a story for later.

After I walked through the pit, came out on the other side, and asked for God's forgiveness, I was determined never to be in that place again.

So I began to walk a tight rope to ensure I never fell into the ugly low place. It was an acrobatic performance of epic proportions, sans the glittery leotard. My very own circus of self-condemnation.

Day in and day out, muscles taut, I balanced. I focused. I inched my toes forward in tiny increments and waited for the swaying rope to find equilibrium. I practiced my mental acrobatics and told myself constantly:

Be a good Christian.
Don't mess up.
Do it right.
Little sins lead to big sins.

I don't know about you, but I am neither an acrobat nor a gymnast, nor an athlete at all if we're being honest, and until they make reading books an Olympic event I'm not destined to medal in any type of "sport."

I became a "performance Christian." I said the right things, did the right things, displayed just the right amount of admission of my failings with appropriate humility. But the big ugly things I'd overcome with Christ...those I kept hidden away backstage, never ever to be brought forth into the brightly lit arena, lest they be judged by a condemning audience.

And as with most things I justified it, and God and I had a talk about it. My conversation with God went something like this:

ME: I have a desire to write and to speak your truth and light to the world, especially to women.

GOD: That's great! I created you with purpose.

ME: It seems like every day you show yourself to me a little more and I become a little bit better than I was the day before. I want to share our relationship with others, to give them hope.

GOD: Do that. I enjoy talking with you every day and spending time with you. I delight in you!

ME: I will just keep telling people how you're involved in all the little things every single day.

GOD: Wait…what? What about the big stuff?

ME: Well sure, I mean, you care about world peace and orphans and stuff, too. Like *global* stuff, but that's not really my niche.

GOD: No, I mean YOUR big stuff. The stuff you put under the barrel. I have forgotten what it was, but I know you hid it under there. You know, the enemy is the one who handed you that barrel.

ME: <*sits slack jawed and wide eyed in silence*>

GOD: I gave you grace, and forgiveness. It looks like brilliant white light. I intended you to shine it on your sisters. But the enemy immediately handed you a barrel, and you took it and placed it over my light.

ME: I took a barrel. <*pictures the scene, "I carried a watermelon," from Dirty Dancing*>

GOD: It's okay. Just take it off and give it to me. My Son will take care of it.

ME: But…

GOD: Go ahead…I knew you were going to say that.

ME: But… If people see what's under the barrel, I won't have any credibility.

GOD: There is no credibility in the sin itself, but your credibility lies in your redemption. It's in that Holy Spirit light underneath there. Give me the barrel.

ME: But…

GOD: Give it.

ME: Well, okay, seems simple enough. Here you go...<*trembling*>

GOD: You should be able to see clearly now that you've uncovered the light. You don't need to balance on that tightrope. My path is right there under the rope; step down. Besides, I knit you together and I know exactly how much coordination you have; I don't want you to hurt yourself.

ME: I know, right! Good lookin' out! (*Yes, this really is how God and I chat.*)

GOD: The path is wide enough. Quit tiptoeing and run after me. Be bold. Live. Be human. Make your mistakes. Repent. Forgive yourself. Forgive others. Minister. I made you for such a time as this. Get to it.

ME: Cool, you're so awesome! Love you!

GOD: Love you more.

Sin is ugly. Especially big sin. And it has far-reaching consequences. But even a big sin isn't the end of your story. You still have a job to do. God still has a plan to use you for his purposes. Kingdom purposes. You will be most effective to the Kingdom *after* you've sinned, repented, and came back to Christ. You'll minister from your pain, and your gratefulness for God's forgiveness. It will develop in you an empathy and compassion for others going through the same season, so you can help guide them.

Nothing is wasted. God will use every single screwup to shape you into who he created you to be. If you've learned a lesson, use it! Chances are there is another girl out there who has done the same dumb things that you have, or they're about to. But if you let your shame silence you, she'll never know what hope lies on the other side of her own mistakes. The enemy would like nothing more than to duct tape your mouth with dishonor and convince you that your mistake is too big to be redeemable. Your mistake may be big, but God's grace is bigger. And there is a girl out there who needs to hear about it. This is about more than you. This is about freeing someone else who has been shamed and silenced.

So stop hiding your light and step off that tightrope of perfection. You need my stories and I need yours!

God, Let Me Tell You How to Do This

Have you ever prayed for something and then in the same breath told God *exactly how* he should accomplish said request? I have. About a million times. It's not that I don't trust that the Almighty is able to accomplish whatever he sets his mind to; it's just that, you know, maybe he's soooo busy that I could offer some parameters or guidelines that would make the process go more smoothly. I mean, I'm living down here right smack dab in the middle of the situation at hand, so I'm intimately familiar with the details and I'm just trying to be efficient and helpful. At least this is how I justify it to myself. It might also have something to do with the fact that I'm a teeny-tiny bit of a control freak. God wired me this way so there is surely some method to his madness, but it's probably not because he needs me to help him run the universe.

Whatever the reason, God allows me to rattle on about the best way I think he should handle whatever drama that I bring to him, and I can't help but think that he alternates between covering his mouth with his hand and shaking with laughter at my absurdity, rolling his eyes heavenward (or to wherever God rolls his eyes) and furrowing one brow while raising the other in a stunning impersonation of The Rock.

During my tenure as a single woman, but before the idea of cat lady had fully set in, I determined that it was time to take my dating situation

more seriously and form a game plan. I was going to venture into the world of online dating. I had been set up by friends, and been out with a couple of nice guys, but the magical Nora Roberts trilogy type of love and chemistry was eluding me. So I thought, why not market myself like some amazing yet practical and cool new product, so I can fish from the dating pool of the whole entire internet world?

Why not indeed?

Because weirdos.

That is why not.

If you have found your soulmate on whatever *e-synchronization* dating site you chose, or one designated solely for those who grow crops, then I tip my hat to you. You have persevered through the infinite sea of dating possibility and successfully escaped being devoured by the weirdo shark. Clearly you have come out not only unscathed but with a fine catch to call your own. I wish you all the happiness in the world. The online dating machine of the internet world truly does work for some people, just not for *this* girl.

On paper it seems as though dating in this technology-driven fashion would be perfect for a control freak such as myself. You type in the exact parameters for what type of person you are seeking for your mate, and you create a profile for yourself consisting of only your most desirable attributes. Add a few self-deprecating yet adorable tidbits about yourself. Attach a fun yet laidback, yet serious and smart, yet whimsical, yet goal-driven photo with just the right amount of beach wave…and go! It's like ordering your groceries online. You basically avoid interacting with humanity to any degree. Perfect for the introvert. You choose your potential match and drive to meet Mr. Soulmate Material at a well-lit public place, where you can nibble on appetizers and get to know which parts of his profile are completely fabricated. The first of which is usually his height.

I mean, I guess it could work…if we just stayed seated for the rest of our lives. Did he really think we would never stand, or that I would arrive

barefoot, giving him the two-inch-thick sole advantage? Who does he think he's kidding? If he's six-foot tall, I'm Mary flipping Poppins.

I sat down at my computer to create a profile that would make me sound amazing, but also authentic.

GOD: What are you doing?

ME: Creating my dating profile.

GOD: Oh, I see. Why?

ME: I really want to find the right person who's the perfect match for me. I don't want to casually date. I want a real relationship that lasts. There is a science behind this, the commercial said so.

GOD: Didn't you already ask me to send you someone?

ME: Well, yes, but I'm sort of tired of waiting, no offense, and this is a super easy way for you to choose the perfect guy for me.

GOD: My timing is always perfect, you know. Did you consider that maybe it just isn't time yet?

ME: That's okay. I'm not like in a super big hurry or anything; this is a monthly subscription, so I can cancel at any time. What do you think of this profile picture? Does it say fun, but also responsible?

GOD: *<sighs>* It's a great picture. You were beautifully and wonderfully made. But you know, you don't have to do this. If you would just trust me and leave this request with me, I could—

ME: Oh, right…right, I know, and I totally trust you and everything… totally… I just want to see what's out there and then it's all you, I promise.

GOD: *<I did create her stubborn and strong-willed…>* Really? Because it sounds like you're trying to do this your way and then get my stamp of approval on it later.

ME: Whaaat? Noooo, of course not. I prayed for a husband and I gave you all the specifications of exactly what type of man I'm looking for. You still have my list, right? Tall. Funny. Christian. No kids because I've done my time, am I right? No cops because not looking to fish from the workplace pond again…enjoys reading and—

GOD: Oh, yes, my dear girl, I remember ALL the specifications.

I know exactly what you need. I numbered all the hairs on your head, remember? I knitted you together and I've known you for a very, very long time. If you insist on trying this, I wish you well.

ME: Thanks, God, you're the greatest.

GOD: So I've heard <*chuckles*>. Don't forget I love and value you more than all the birds of the sky and all the beautiful flowers of the field.

ME: Awww, thanks, I just love you so much! Oh, I almost forgot to add all my interesting hobbies…

I wasn't doing anything sinful or wrong by online dating. I was just doing it *my way*. I had asked God for a husband. In fact, I had requested a very specific make and model for a husband. And now I was essentially telling God how to deliver said husband. I wasn't trusting God with what I had asked him to do. I was taking back control of the situation instead of letting God be God. And God, knowing better than to argue with me, let me try it my way.

After I perfected my profile and clicked SAVE, I was ready to start this dating adventure and find my soulmate. I'm a girl who likes time-lines (which is probably why I was tired of waiting on God's), so I figured within a few months my future husband and I would be starting our relationship and heading toward marital bliss. As it turned out, it didn't take that long for my quest to reach a conclusion.

Three days.

That's how long I managed to keep my profile active after the weirdos swarmed.

Three days and the profile was deactivated.

Here is a just a sampling of some of the drama that unfolded in those three days:

1. Minutes after I activated my profile, I received my very first notification that I had a match. I excitedly clicked on Mr. Right's profile to discover staring back at me the face of the man I had most recently been dating prior to this online escapade. And

judging by how long he had been an active member, he had created his profile while we were still in a relationship. *Seriously?*

2. I was messaging back and forth with a potential match and I asked if he had any children. He replied no, he did not, but he did have numerous bearded dragons and he liked to ride around town on his bicycle with the little darlings in a handlebar basket covered in a baby blanket. I laughed at his quirky sense of humor. Then he sent me a picture of himself and his babies in their basket. *Nope.*

3. I received a message that contained only one sentence.
 "I want to touch your hair." *I can't make this stuff up.*

The online experience wasn't all bad and I chatted with some very nice people. I met a man who was a police officer in Hawaii, a real-life Hawaii Five-Oh. I even managed to go on a single date with James Bond. True story. That's his name. I saw his driver's license. But in the end the online experience was just too weird for me. After that I gave up on the man-fishing expedition and just waited on God. And in no time at all my husband walked into my life.

You may be wondering if my husband met all my carefully laid out specifications.

No.

No, he did not.

He *is* very tall and funny and those are literally the *only* corresponding matches from my exhausting list. I only gave a sampling of the list previously, but it was thorough and mostly ridiculous. In fact, God went completely opposite of what I requested and brought me a police officer who has never in his life willingly read a book. Oh, and did I mention he had THREE kids? Three LITTLE kids. I'm talking about car seats here. Add that to my three who were nearly GROWN (ya'll, I was SO close to done) and we have a *Brady Bunch* situation happening over here. Three boys. Three girls. All I'm missing is the maid. God has a sense of humor.

And yet...God managed to deliver into my life the most perfect

match I could have imagined. We have more chemistry than a thousand high school science labs. My hand fits snugly inside of his. He is the kindest, most thoughtful person I know. And being with him feels like coming home. Yet this is not a match that a computer software program would have made based off the criteria I *thought* was most important. I thought my list of wants and needs was from my heart. But my heart can't be trusted. It's dumb. Like chalky valentine candy imprinted with pithy expressions of love. I based my "heartfelt" list off leftover feelings I had from bad experiences, and unmet and unrealistic expectations.

Sometimes we don't even know what we need or want. But God does, and if we just let him take over he'll hit it out of the ballpark.

GOD: I told you so.

GUARANTOR: A SINGLE WOMAN

I married my first husband at a very young age, and after twelve years of marriage, a divorce, and a three-year reconciliation period my marriage was truly finished and dead. The devastation that followed this failed marriage left me in the darkest place of my life. My faith kept me just above the waves that tried to drown me. And God brought me back into the light, healed my heart, and fully restored me.

I had always been a fan of the book of Isaiah and have an obvious affection for the verse 54:10, but it was during this season of my life that I noticed the lines before them for the first time.

You were like an abandoned wife, devastated with grief, and GOD welcomed you back, like a woman married young and then left, says your God. Your Redeemer God says: I left you, but only for a moment, now with enormous compassion I'm bringing you back. In an outburst of anger, I turned my back on you – but only for a moment. It's with lasting love that I'm tenderly caring for you (Isaiah 54:6–8, *THE MESSAGE*).

These words changed everything.

They gave me a life raft to hold on to during what was to be a very dark and hard place to navigate.

"Guarantor: a Single Woman"

The words jumped off the page at me, clawing at my eyes like a savage cat. Words are powerful, and this set of words reached off the page with spindly cold fingers and squeezed my windpipe, keeping me from breathing in a full breath as my emotions tried to push their way up and out. They were emblazoned on the paper in such an offensive old typewriter font. This hateful collection of letters made me feel shame…and I hated them for it.

These words appeared in the mountain of paperwork I signed as I bought my very first home of my own, post-divorce. I still signed my married name. That's who I was, but this one line mocked me and reminded me, should I ever try to forget, that I may be using my matrimonial signature, but I was still a *single woman*. This phrase—along with *divorced, unwanted, uninvited, unloved, unworthy,* and *failure*—became my identity.

I'll also throw in cat lady, because that is the fate I had resigned myself to. Because that is what all sane thirty-something divorced women settle in to as their new comfort zone. I assumed I had been given my one shot and failed, so that was that. I reasoned that I had been married, had three utterly amazing children, finished college, had a career, so I'd done all the stuff girls were supposed to accomplish. On to *Netflix*, reading endless stacks of books, ice cream, and cats. Sounds good, right? If you're feeling a little sorry for the old me, it's okay. I felt sorry for me back then, too. Self-pity was the new black, and I wore it exclusively.

They were just words on a paper. That's it. But they had a profound way of seeping into the tender places in my heart where divorce had left a wound. I tried to stick bandages on it, and a little gauze and ointment here and there. But what I had not done was settle in with Jesus for some real heart surgery. *Who wants to do that?* Healing from surgery is long and hard and painful. But you know what is even more excruciating? Suffering with an obnoxious bleeding wound the rest of your life. But that is what a lot of us do.

We let the wound scab over. Rip off the scab. Rinse with condemnation and repeat. We rationalize that this is less painful than getting down

low with our God and facing what people have done to hurt us, and what we have done to hurt others. And we would be right—it IS less painful… for a time. But the difference is that there is no permanency of healing at the end of it. In fact, there IS NO END to it.

As I sat in the office of the title company, signing documents, I was squarely seated on the Ferris wheel ride of unfinished business, spinning around and around. Now, had you asked me, I would have said that I was "free" and had dealt with the divorce and all the messy attributes that accompanied it. But I was anything but "free." I was strapped and buckled securely on the Ferris wheel ride with no way to get off the ride of my own volition. It would take someone else running the controls to get me down safely and take me out of that seat.

We cannot stop this type of ride on our own. Only Jesus truly has the controls and can do that. But here's the kicker…we must ask to get off the ride. We have free will and he will allow us to stay on as long as we like. We unknowingly collect carnival tickets called *doubt, shame, guilt, unworthiness, abuse, sin, condemnation, hatred, envy, jealousy, depression,* and *fear*. We throw the tickets down to Jesus and stubbornly sit fast for one more spin around the brightly lit wheel. We will ride this way until we finally get tired of the spinning and become nauseous from the brightly lit lights and the blaring carnival music on repeat, and we ask to come down.

I eventually reached this point, and while face down on my bathroom floor I asked Jesus to get me down off the Ferris wheel.

I stood in the shower in the post-divorce house I had purchased by signing the offensive single-woman paperwork. My shoulders slumped and the weight of each drop of scalding water from the showerhead felt like ten-pound weights slamming into me. I had finally reached the point of giving up. The grief and loss and feelings of being unwanted, unloved, and rejected were manifested in a physical exhaustion too heavy to bear.

Leaving the water running, I used my last bit of strength to push the shower curtain aside and climb out. I didn't reach for a towel. I didn't wring the excess water from my hair or wipe the tears from my lashes. I didn't care. With wet, dripping hair stuck to my face and neck, I sunk to

my knees and first my forehead then my cheek found the cold tile floor. My body wracked with sobs and my throat released a heart hurt that sounded like a wounded animal. Occasionally words and short phrases would form around my anguished cries.

ME: Jesus…
ME: I just can't anymore…
ME: Please…

I don't know how long I was there. Eventually something changed. I was no longer aware of the cold, or the wet, or anything else around me. Slowly I began to hear sounds coming from the world outside the bathroom window. The sounds of birds, cars, and lawn mowers began to slowly enter my conscious mind. And a peace was laid over me, which felt like a large, warm, luxurious robe.

Everything that had been tearing and ripping apart inside of me calmed.

GOD: It's time to get up. This season has passed. It is time to move on to what is waiting for you. I have plans for you. Trust me. I will be with you no matter what. You are my daughter. You are royalty. You have a tremendous future waiting.

ME: <*breathing, listening*>

GOD: Your marital status is not your identity, and your worth is not tied to a man. Your worth and identity are clothed in royal purple—you are a daughter of the King. My love for you is all you will ever need to fill you, and I will never leave you.

He was right that day and he has been right every day since. My story is still being written, and so is yours. The conversation I had back then with my Heavenly Father was profound and it changed my life. All my head knowledge about the love of God became heart knowledge on the cold floor that day. I felt a shift in my spirit that course corrected me and

placed me squarely on the path that he had intended for me all along. I just had to be desperate enough and needy enough to give up and let God take over.

ME: I didn't even have the words that day on the floor to tell you what I needed.

GOD: I didn't need your words. The Holy Spirit was talking a mile a minute on your behalf.

ME: But I couldn't even think of what I should ask for.

GOD: That's when the Holy Spirit works the best. When you stop and let go. That's how I designed it.

ME: Had I known that would happen I would have stopped worrying and crying a lot sooner, so the Holy Spirit could have shown up.

GOD: I was always there with you, waiting. You had to drop those earthly walls of defense that you constructed so I could come in close enough for you to feel it and get up.

ME: I was just so tired…and…weak.

GOD: Tired and weak are open doors for the power of the Spirit. I won't force my way in those doors. You must unlock them, open them, and invite me in.

ME: I was so consumed with my desperation that I didn't even know I was inviting anything or anyone.

GOD: You called on my Son. He promised he would always show up. If you ask, he will do it.

ME: But all I could say was his name.

GOD: That's all he needed. The Holy Spirit handled the rest. He knew all the words your vocal cords did not have the strength to make. He poured them all out to my Son. The Holy Spirit groaned and pleaded for you. My Son heard all of this and he had such compassion for you. Your desperation broke his heart. He asked me to get you up.

ME: And you did. I didn't think it was possible. But you did.

GOD: Of course I did. I love you more than you could ever understand. When you hurt, I hurt.

ME: It was so very dark then…

GOD: I know, my daughter. But it's light now. You remember that dark place and now you recognize it in the eyes of others.

ME: Thank you for not leaving me there on that floor. For getting me up.

GOD: I would do it again and again.

God does not need our fancy words or our carefully memorized scripture in order to rescue us. He feels our hurt. He collects our tears in a bottle and the Holy Spirit groans with the pain that we cannot adequately express. Sometimes all we can muster is the uttered name of Jesus. That is powerful. And that is enough.

ORDINARY

Lord, let me see you in the ordinary. That was my prayer one gray and rainy day.

To be honest I would like to see something miraculous as well. Every day I'd like to be blown away by an overwhelming sense of the Holy Spirit presence of God. I mean, who doesn't want to see the manifestation of Jesus doing something that glitters and sparkles and completely blows your mind? Well, maybe not until I've fully woken up and had my morning energy shot. I don't exactly bounce out of bed at dawn and I'd like to be coherent and mentally present for Jesusey miracles and wonders.

There was nothing miraculous about this day; it just felt...*meh*. Nothing bad was happening. I wasn't particularly stressed out about anything. But I wasn't necessarily joyful either. Just...*meh*. Maybe it was because clouds covered the sky. Or because rain sprinkled down periodically. Or maybe because I was returning to work after a romantic vacation with my husband, knowing we wouldn't see each other much this week as we played catch-up with the stacks of papers on our respective desks.

Meh. It wasn't necessarily a negative attitude—just ordinary. Which was why I felt compelled to pray my *ordinary prayer*. I didn't want to miss the Lord in my *meh*.

Something I've been learning is that the ordinary little things matter. We know in our heads that God cares about all the aspects of our lives.

So it makes sense that this would include all the ordinary little things we deal with day to day.

Luke 16:10–11 (TPT) says:

> "The one who manages the little he has been given with faithfulness and integrity will be promoted and trusted with greater responsibilities. But those who cheat with the little they have been given will not be considered trustworthy to receive more. If you have not handled the riches of this world with integrity, why should you be trusted with the eternal treasures of the spiritual world?"

Well, this seems like a lot of pressure. What kinds of things are we talking about here? If I do all the "little" annoying things just to get them done, does that count? If I'm bitter and begrudgingly plowing through my task list, does that cancel out the integrity part? Most women have a laundry list (pun intended) of things to manage that don't exactly spark joy. No one *wants* to pick up, wash, dry, fold, and put away all the underwear in their household, and then do it all over again—a gazillion times. And if you do, then we can't be friends.

Also, who decides what the "riches" are exactly? Your riches and my riches might be two completely different things. I mean, I keep the fine china polished and put away in the fancy china cabinet, so that qualifies as being trustworthy with my riches, right? I'm kidding. I don't have china. I have paper plates, but I do manage them with faithfulness.

ME: Am I handling the "riches of this world" with integrity?
GOD: What do you think?
ME: I certainly hope so. I know that I want to be trusted with the subsequent "eternal treasures." If for no other reason…than I'm certain at least some of your eternal treasures are pink and sparkly. And you know that glittery beautiful things bring me joy.
GOD: <smiles>

ME: Okay, but seriously…what do you mean by "riches"? Like, anything that you've blessed me with?

GOD: Yep.

ME: That seems subjective.

GOD: Look at the obvious stuff.

ME: Okay, I have a home for my family.

GOD: Which means?

ME: I am tasked with taking care of that home.

GOD: Which means?

ME: Cleaning toilets.

GOD: <*chuckles*>

ME: Come to think of it…I may need to bless my teenagers with the privilege of cleaning said toilets, so they, too, might experience handling these riches with integrity and secure some eternal treasures for themselves. I mean, I don't want to be selfish, right?

Cleaning toilets is ordinary. It's also downright disgusting with six kids at home, but maybe if I recite *eternal treasures…eternal treasures… eternal treasures* as I clean them, it will feel more holy. It shouldn't feel so beneath me or burdensome to take care of the things he's given me. In fact, if the Lord walked into my bathroom and asked me to please clean the toilet for him, as it would be impactful to the Kingdom and it would please him, I would do it without question and likely with more passion that I've ever done anything else in my entire life. Of course, to be fair, if Jesus walked right in like that, I would have already fallen to my knees anyway, so why not put the Clorox to good use while I'm down there?

Maybe toilets are too dramatic of an example.

On this particularly ordinary day in question, I did not want to sit at my computer and sort through all the mundane paperwork that had accumulated during my vacation. So instead I crossed my arms and heard Heather Land speak forth from my mouth.

ME: I ain't doin' it! <*crosses arms defiantly*>

ME: Not only is my to-do list ordinary, but it's just downright boring.

GOD: Do you see ME in your work?

ME: Well, when you put it that way... <*sheepishly remembers that I did ask for this*>

GOD: You're welcome.

ME: Um...thank you? I'm guessing that what you're saying is *maybe— just maybe*—I should not only complete these tasks with integrity, but with praise.

GOD: I equipped you for this. I placed you here to do this.

ME: But it doesn't *feel* like purpose-driven work... <*insert dramatic whining here*>

GOD: But there IS purpose in it—because I AM in it.

My job may not always (or ever) feel like I'm serving God, doing his will, or living out my purpose, but THIS is right where God has placed me, and he does nothing by mistake. He wastes nothing. It's not like he just plopped me down in this place with these tasks to keep me busy making hypothetical widgets while he is busy running the universe. He specifically designed me and wired me to "get" the type of work that I do. He made my fingers cheetah fast on the keyboard and my mind capable of opening a thousand mental tabs so I can multitask like a pro. God uses all our experiences. I can see the experiential threads he's woven through- out my life. There have been uncountable instances where I was going through an experience and I could not for the life of me figure out how it was relevant to my world, only to find later that something I learned, saw, or did, or someone I met, came back around to be a part of something bigger later on down the road. I just couldn't see the entire road map and how I would wind up where I did.

Maybe, like me, you've felt this way in your job or in your every- day responsibilities at home. Maybe God is growing and preparing us for more. Maybe we're in *Kingdom training*. Maybe all these ordinary tasks and sometimes awkward and downright uncomfortable things I must do

(can anyone say PowerPoint presentation?) are shaping me into a woman he can use for something far greater than I could imagine. Maybe all your ordinary stuff is also training and shaping *you* for something bigger and more magnificent than seems possible right now. Maybe your rainy gray days are building blocks for the great plans and prosperous future he has for you.

Meh…maybe.

Ground Truth

Working in emergency management in my career meant that I got to learn a lot about the weather. Although I'm far from a meteorologist, I had to be cognizant of upcoming storms of various kinds in order to warn and prepare the public. Aside from licking my finger and holding it in the air to determine wind direction, I often consulted the real experts at the National Weather Service. These guys know weather. I mean, they live and breathe this stuff. I have never met a group of folks who were more intelligent, dedicated, passionate…and, well…geeky, but in the best possible way. They have so much scientific knowledge and cool equipment that helps them formulate storm models that give us all the probabilities of what the future holds. They're like nerdy fortune-tellers.

But as it turns out, even with all the gadgets, radar, and computer software, it all comes down to the fact that they are just *really* good at making educated guesses.

The very first nationally televised weather forecast was in 1949 by Clint Youle. All he had was a paper map on the wall with some plastic over the top of it and a dry erase marker. He was drawing on the plastic over the top of the map so people could see clearly marked areas where the dangerous weather was located. He was determined to get his point across visually to the audience. He cared about people and keeping them safe.

A lot of these weather folks are just like Mr. Youle. Meteorologists

are compassionate. They really want to get this weather thing right, and get their point across, and they want the people watching their forecast to be safe and take measures to protect themselves when necessary. I'm guessing prior to 1949, if the radio wasn't on you just had to rely on the *Farmer's Almanac* and a good ol' licked finger stuck in the air.

I got to spend a lot of time with these weather wizards and I learned how important it was during bad weather for me to stay in touch with them and let them know what was going on in my little corner of the world. They have amazing technology that gives them a big-picture outlook on what's going on, but they still needed us on the ground to send them photos and let them know what size of hail was hitting the ground, and what kind of damage the wind was causing, so they could formulate a better outlook for the next town over that was in the storm's path.

The most important thing that meteorologists taught me is this:

Ground truth is the key to weather.

Meteorologists formulate a really good idea of what the sky is going to do, then they rely on trained storm-spotters, or amateurs like myself looking out the window to provide proof that the weather is behaving as they expected that it would. Weather radar equipment is amazing, but the fact is, the further away from the radar you get the less accurate the big picture becomes for a specific area. They *need* those of us at ground zero to provide a clear picture of what's up. Until people see and feel what's happening with the storm all around them, it is just a percentage on their television screens. They won't be prompted to take any measures to protect themselves.

Someone who has never experienced a tornado in their lifetime may have to hear numerous warnings before determining that they need to take shelter in the basement. However, someone who has experienced the ferocity of that type of storm will immediately know that they need to protect themselves and will tell others to do so as well. They have experienced a ground truth about tornadoes that could save themselves as well as others.

Ground truth is the key to Christianity as well. We have experienced

many different types of storms in our individual lives. Some we weathered well, and others knocked our boat around and left us clinging to the side, waterlogged and begging for the wind to cease.

As Christians we have learned to recognize the storms that we have battled before. We see their approach in our lives and we stand firm on our faith and the Word of God, and are therefore more prepared to fight the good fight. Others who haven't experienced the same storms may not have the same advanced warning as us. They may not recognize the danger they are about to step into. They can feel the wind whipping but are naïve as to how perilous their next steps could be. They are walking blindly into a raging battle the likes of which they have never faced before.

But we have.

This is where we should be standing with our brothers and sisters and shouting at them to take shelter, because we have survived this disaster before, and we know what lies directly ahead as well as the beauty that lies beyond once the sea is calm.

ME: I have made it through some nasty storms, huh, Lord?

GOD: Yes, you have. And I was always with you.

ME: Some of them seemed like they would take me under.

GOD: And then what happened?

ME: When it was over the sun seemed to shine even brighter than before.

GOD: Would you go back and change it?

ME: No. I was so close to you in those moments. I had to cling to you, so I wouldn't drown.

GOD: You relied on me to protect you.

ME: That's why you allowed the storm to be so fierce, wasn't it? So I wouldn't try to swim ashore on my own.

GOD: I like it when you need me.

ME: So tell me…is thunder just a heavenly bowling match, or are you moving furniture around up there?

GOD: *<smirks>* That's not something you need to worry about just yet.

ME: But you do control weather and all of nature, right? Rain, drought, hail, even frogs and locusts have shown up on occasion.

GOD: I've allowed and calmed many storms.

Those of us with a relationship with Jesus are very close to the radar. We are connected heart to heart with our Creator. But some people are far from the radar and the big picture is cloudy, unreliable, or nonexistent. People need to hear our ground truth about Jesus. They need us to tell them exactly what's up with Jesus, who he is, what he's done in our lives, and how he can dramatically impact the forecast of their future.

As we connect with people we become intimately acquainted with what is causing them to hurt, to doubt, to give up on it all. It is our job then to intercede on their behalf and take that ground truth to God. Pour out to him the anguish that our fellow man is carrying and ask him to take it. Let him know the size of the hail that is pelting his people and paint a real-life picture of what damage it's doing to their lives.

And he's given us permission to do just that. The Bible tells us in John 15:7: "If you remain in me and my words remain in you, ask whatever you wish, and it will be done for you."

ME: You're omnipotent, omnipresent, and probably some other fancy "O" word, so you don't really *need* us to tell you any of this or ask you to take care of people, because you already know what's going on, right?

GOD: Yes, but I *want* you to.

ME: Gotcha…but why, though?

GOD: You know me. They don't yet. I am shaping *you* in this process, too. You are the conduit, introducing people to my Son. Show them how to see and feel my Son by your actions. Share your life with people. Let them see ME in you.

ME: Ohhhh *<lightbulb>*, until people see and feel Jesus in the storm

around them, they're just words in a Bible. They won't take any protective action. I should tell people my truth and the truth about Jesus.

GOD: Right.

People plan their lives around the weather forecast and look to their local meteorologist to guide their decisions about their daily activities. Once you've shared your life experiences with people, and they have some solid spiritual ground truth about who Jesus is, what he has done, and what he *can* do, they can turn to the Word to plan their lives and look to the Father to guide their decisions.

For every good or bad thing that you've walked through in your life, there is someone (or more likely, many people) out in the world who need to hear how God showed up in your situation. Lots of people experience similar struggles, but only one of those people is uniquely you and can uniquely share what your eyes saw, what your ears heard, and what your heart felt. There is no other "you" and there is no other perspective exactly like yours. Share your ground truth with those around you. You didn't experience what you experienced for nothing. You would never hear a tornado warning or spot a funnel cloud and silently take shelter in the basement and tell no one around you, especially if you'd experienced the devastating damage it causes firsthand. You would likely shout for everyone to take shelter and help as many people to safety as possible. Your ground truth you learned in life is no different. God made you prepared to weather this particular storm and equipped you in the process to help protect others as well.

Dear Younger Me

H ave you ever sat down and tried to write a letter to your younger self? What would you tell her? Would you warn her against making all the youthful teenage mistakes you know she's going to make? And if you did, would you still be the same person you are today? The one good thing about getting older is that it provides you with wisdom, some of which was hard-earned.

Dear younger me,

You are loved. Let me just start by saying that. I know you think there are 143,216 things wrong with you, but you're wrong. I also know that when you read those first three words you felt uncomfortable because you don't think you're worth all the syllables it takes to say them out loud, but you're wrong again. I know that on the outside you're pretty good at acting like you believe it, but I know the inside parts of you that feel all the feelings. I know this…because I'm *you*. *A later version of you.* A much older, cooler, sophisticated, and wiser *you*. *Current you* just snorted with laughter, but what does she know? I'm here to let you in on a few secrets from the future that will tremendously help you. I'm hoping the fact that *you* are the one saying all of this will be intriguing enough to make you take heed, because heaven help

anyone else who tries to tell you what to do. Yeah…that's a bit of a character flaw we still have.

Boys

I could legit write you an entire book on this, but it would mean writing a trilogy because I'm still on the learning curve with this one. What I can tell you is that relationships are great. They are fun, fulfilling, and awesome and carefree, especially at your age. Enjoy them. Just don't *become* them. You haven't figured out exactly who you want to be yet, and you aren't entirely comfortable in your skin, and that's fine. But as you're seeking who you are, you don't have to morph into the mold of whatever boy you're spending time with. I know this is hard to see from your perspective, because it feels like you're just being you, but there will be a pattern that emerges where you find that the current version of *you* keeps changing, depending on your relationship partner. Just keep looking for the "real you" in there, because she's pretty great. When you find her, hang on to her. There will be a lot of seasons you'll go through with her, and life will ebb and flow in so many ways you can't even imagine it, and you'll lose her for a bit. But she's always there, and you'll find her again and bring her back.

Don't set down all your big dreams for anyone. You are smart, and your plans are good. They were not put inside of you by accident. You were made uniquely with talents and little quirks that make you like no other single solitary person on the planet. The desires you have and the things that come naturally to you were put inside of you with intention. You did not randomly land on something you are good at. Use it.

Your worth is not determined by whether you have a boyfriend or not. Later you'll spend some time alone (finding her again) and you'll wish you'd taken the time to do it when you were younger. It will be one of the best, hardest, and most rewarding seasons of your life. And you'll wonder during this period if

you'll be alone forever. You won't be. I promise. However, you will at one point consider becoming a full-time cat lady and spending your free nights crocheting clothes for your little darling (it was a dark time, do not judge).

People Are People

People are not objects. Do not treat them as such. Sounds simple and logical, right? Not so much. You are inherently selfish and looking out for number one. It is your nature. I say this out of love and honesty. I'm not picking on you; everyone struggles with this. You've heard of the golden rule, right? That's an *actual* thing you're supposed to do, and get this: you're supposed to treat people kindly even when they don't treat you the same. WHAT? Yep, you're just going to have to trust me on this one. It's counterintuitive for sure, but well worth the effort. It feels funny, like putting your shoes on the wrong feet. Just go with it. You'll adjust.

Spend time with people. If feels like you have forever to do that, but you don't, and you have some really great people who share DNA and space with you. Listen to Grandma every single chance you get. She is trying to teach you some valuable stuff; she cares about what kind of human being you turn out to be. Being in her kitchen is like taking a free course in "adulting." I could fill pages with all the things that you will wish you had paid more attention to and rolled your eyes less at. She loves you fiercely. She feels big feelings and sometimes that seems weird and scary to you, but it's because you are so much like her. She will one day open her heart even further than it's ever stretched before. She will love *your* children and tuck them into the open spaces she created in her heart. Treasure this with everything inside of you, because she won't get to meet all of them and that will leave a longing in your heart that will feel tangible enough to touch.

Tell Them

I wish that I could tell you that everyone treats you fairly and you come out unscathed with your heart intact. Not your story. Sorry to disappoint. People are going to let you down, and you are going to let others down, sometimes intentionally and sometimes not. Your heart will get broken and bear some scars. But before you despair over this seemingly bleak future, just know that you come out a strong, faith-filled warrior at the end of it. The heartbreaks (yes plural, ugh…sorry again) were purposeful and created in you a strength and an empathy and compassion for others that you could not have manifested on your own. You will learn through your own tears and soul ache to treat others more gently and be able to discern that others' painful stories are leading to a bigger and better chapter of grace at the end. They won't be able to see it yet because their eyes are cloudy with tears and disappointment that are so heavy they can't even look up. They will be busy trying to take the next shuddering breath. So you'll have to tell them. Tell them how grace wins in the end. Tell them that nothing can stand against them. Tell them that the pain is okay to feel, even necessary, but they aren't to *live* in it. Tell them that it's a working piece of a greater plan that is going to bless them so much they will look back and be grateful that they experienced it just exactly as it played out. Tell them that they are loved so immensely that their fragile human hearts could not possibly contain it.

Tell them about Jesus.

Tell them how he is weeping with them, and fighting for them, and standing guard over them, and stitching the broken pieces back together as they mourn. Tell them all this with confidence, looking directly into their eyes. Tell them that you know all this because you have lived it and Jesus brought you by the hand to the other side of the fog and clouds of disappointment,

rejection, and pain and dressed you in new clothes of grace and forgiveness and blessings you didn't even know enough to ask for.

Tell them.

Cut Yourself Some Slack

If I could give you one solid piece of advice, it would be this: *Girl, chill out.* You do not have to be perfect and control every… single…dang…thing. You cannot micromanage other people and you cannot control their happiness, nor can they control yours. Sometimes things are out of your control, and that's okay. Life is going to shock you, and amuse you, and shove you from behind and run away like some bratty neighborhood kid. The ride you're on will be twisty and you won't always know what's around the next bend. Sometimes you'll plan out your nice, straight, peaceful route, then without warning you'll fly off the road unexpectedly. That's just life. Get back in the car and drive out of the ditch. Trying to control life is like trying to juggle wet cats; it feels awkward and a little dangerous. Stop trying to plan out everything and everyone to fit into your neat and tidy little boxes and accept that life is all about how you handle plan B. And it's a beautiful life.

Say the Words

I'm sorry and *I love you* cannot be overused. If you feel them, say them. They're important.

You Are Not Alone

You know that feeling you've always had like you have a cool imaginary sidekick who hangs out with you all the time? You aren't crazy; it's Jesus and he's literally been there the whole time, protecting you from all the stupid things you've tried and cheering you on when you got it right. You'll meet him properly one day and you'll be thick as thieves, the best of friends. You'll tell

him every little problem of your day and he will show up time and time again even though you're sure that he must be exhausted by how needy you are. But amazingly he never tires of you and he actually digs how much you need him! He's pretty terrific and you'll find that he is someone who will never *ever* leave you or abandon you, even when you test his limits. And test them you will. You'll stomp your feet when you don't get your way. You'll pout. You'll ignore him and push him away and talk crap to him. But he's patient and eventually you'll say you're sorry and ask him to come back and be with you again. And he will.

Every. Single. Time.

God loves you so much that you wouldn't understand it even if I could come up with the proper words. You'll get a teeny-tiny glimpse of how much he adores you when you love your own kids, but even that is a mere glimmer to how much HE loves your kids even more. It is indescribable and lovely, and you will smile with joy each day, knowing how cherished you are. I know that seems strange to you right now and you can't fathom that someone so average and ordinary could hold such value, but that's okay. You don't have to grasp it all right away; he's willing to bum around with you until one day you stop and you really look at him, and then he'll smile back at you and say, "Hey, beautiful, there you are."

GOD: Well done.

ME: That was harder than I anticipated. I'm glad I can see so clearly now how much you love me.

GOD: As far as the east is from the west.

ME: Hey, why didn't I get to know you sooner?

GOD: I was pursuing you.

ME: I guess I was a little slow figuring it all out.

GOD: But you did, like I always knew you would. You drew close to me.

ME: Hey, thanks for not ever giving up on me.

GOD: I will *never* leave you or forsake you. I promise.

ME: I was most definitely stubborn and wanted to go my own way, but you came after me anyway.

GOD: I chose you.

ME: It's so cool that you chose this life for me. I know I don't deserve all that you've blessed me with. And yet you just keep surprising me with more and more, the closer we get.

GOD: You are holy and dearly loved. I delight in you.

SISTER-SISTER

GOD: Stop it! That's your sister!

These were the words that God sort of whispered—sort of shouted—to me. Sometimes my conversations with my Creator are like a gentle whisper. But at other times, as in this case, not so much. I didn't audibly hear this correction in the physical world, although if I could tune in to the Lord like a *Pandora* channel, that would seriously improve my discernment game. His words slammed into the *conscious, thinking* part of my brain in that way that you know isn't a thought you came up with on your own. You can tell it's the Lord talking, and it's not a thought manufactured by your own witty, charming brain cells because of the following:

1. It goes completely against whatever thought pattern you were just moments before formulating.
2. It's convicting. And you kinda don't like it. Like at all. Like you scrunch your face up and fold your arms in true pouty-toddler fashion.

I would like to say that I immediately bowed my head in reverence and that my properly chastised heart asked for forgiveness and *took captive* my unkind thoughts.

Nope.

I would also like to say that God nipped this issue in the bud while it

was still in the thought zone before it had a chance to vomit out through my gossip hole.

Nope.

The ugly truth of the matter is that this hand slap from my Heavenly Father happened weeks prior and that I continued to justify spewing my opinions whether I was asked for them or not, and in complete honesty I was never asked for them. I just offered them up whenever and to whomever would listen. And although I almost immediately thought this was going to be something I should write about, I didn't even open my laptop...because that would be admitting that I was in the wrong, and that was not a place I was ready to go yet.

Gross.

This wasn't my actual sister in the same mom-and-dad sense of the word. In fact, our blood does not tie us together in the physical world at all. But regardless of how detached from this woman I was in my mind, as soon as God told me, "Stop it! That's your sister!" I knew exactly what he was getting at.

GOD: I said stop it!

ME: Okay, but she *isn't* my sister. *<defiantly sits with arms folded>*

GOD: She is a daughter of the King. Just. Like. You. No better and no worse than you.

ME: But...I don't *like* her!

GOD: I created her to love her. I have a purpose for her. I delight in her just as I delight in you.

ME: So why do *I* have to be nice to her? Can't you just love her, and I'll keep...not?

GOD: *<frowns with folded arms>*

ME: I don't want to have a relationship with her. *< takes pouting to next level>*

GOD: *I* want a relationship with her.

ME: So have one!

GOD: I want you to show her our relationship. I desire to bless her as richly as I have blessed you.

ME: But that's not fair!

GOD: *<cocks one eyebrow and waits for me to come to my senses>*

ME: Oh…I shouldn't have said that. What Jesus did for me when I didn't deserve it wasn't exactly fair, either.

GOD: You were worth it. She is, too.

ME: I'm really sorry.

GOD: I forgive you.

ME: How do you keep forgiving me when I am such a giant brat?

GOD: My grace is enough. It never runs out.

I'm sure my behavior while I was slamming this *sister* of mine was less than delightful to God.

But thankfully God is full of grace. Every. Single. Day. Because I need a good dose of it on the daily. And especially during my sister-slamming rampage. I know God's love for me doesn't diminish when I open my mouth and stupid things fall out unbeknownst to me and completely out of my control. Okay…maybe there was a tiny bit of intentionality in my words. Maybe.

In fact, I have heard these words of God come out of my very own mouth when correcting my boys as they teased and tormented their little sister: "Stop it! That's your sister!" My crazy-wild love for my kids didn't falter in those moments. I didn't for one second consider removing them from my life or disavowing them like a burned secret agent. But I guarantee I was wearing a furrowed brow, a disappointed mom face, and pointing at them to get my message across.

It's no different with God. Sometimes even God must do a little finger-wagging himself and put us in time out when we act like brats.

Did my boys know better than to pick on their little sister? Sure they did. Their "little" sister, for reference sake, is not actually little anymore but is now taller than me and GORGEOUS… Jesus, take the wheel.

And I know better, too. In fact, one of my favorite verses, which

includes God's commandment to *Love others as well as you love your-self*, is literally tattooed on my body. I can't even make this stuff up. This reminder of love and how we are called to manage it is visually available to me every moment of every day…and yet here we are.

Jesus said, "Love the Lord your God with all your passion and prayer and intelligence. This is the most important, the first on any list. But there is a second to set alongside it: Love others as well as you love yourself. These two commands are pegs; everything in God's Law and the Prophets hangs from them" (Matthew 22:37–40, *THE MESSAGE*).

They are pegs that *everything* hangs on. Love God. Love her. It was that simple.

I may not have agreed with the things this sister was doing or saying, but that didn't give me the right to position myself higher than her and turn my opinions into fact. Don't I want grace from other women who don't agree with me? Absolutely. Maybe they are only judging the surface of what I've done or said, and they don't know my heart or the entirety of the circumstances and my past experiences that guided me in that given moment. The least I can do is afford my sister the same type of grace. The Lord knows I've been given boatloads of it myself. How very different would our schools, our workplaces (which honestly resemble a girls' junior high locker room at times), and our churches and friend circles look if we gave more grace to other females than we "thought" that they deserved? Or what if God only doled out to you the percentage of grace that you earned each day? Fortunately for you and me that's not how it works. We get an abundance of grace and mercy that we don't deserve and rarely remember to ask for.

So why are we so stingy when giving it away to others? Particularly other women.

Is it the comparison trap? Do we sometimes feel like if we give away grace to another woman, our own grace account will be overdrawn? Why are we like a needy grace sponge soaking up all that's offered in our direction? We're over here like Bounty quicker picker uppers lapping up all the grace and understanding for our own selves while our sisters are suffering

in a dust bowl of judgement and condemnation. All they need is a drop. A single drop of compassion wrung out from the overabundance of grace we get piled on us that we don't deserve and didn't ask for. Couldn't we eke out a tiny extra bit of empathy for the sister who has found herself being all human and messing up? She feels like she's drowning in dry sand. She feels like she can't do anything right. And we just keep shoveling more dry sand on top of her.

We need to change that.

But sometimes it's hard. Maybe her screw up strikes a nerve with you. Maybe she hurt someone in the same fashion that you were once hurt. Maybe you feel she is justified in spending the rest of her life feeling wretched and guilty. Maybe that actually makes your old wounds feel a little better. Maybe you feel as though the cosmic scales of justice tipped ever so slightly back in your favor because she is suffering due to the role she played as the villain in whatever similar scenario hurt you way back when. Your mind thinks, *She's getting what she deserves. She chose to act the part in this play and now she has to pay the consequences. I don't feel sorry her...*

The curtain closes on her desperation and regret, while you sit arms folded, holding on to your judgement and your justifications. And from somewhere out in the audience you hear clapping. For a moment you feel as though your judgement is being applauded, until you realize there is only one in the room with you and he is there to seek, kill, and destroy. He is thrilled with your sister's fall from grace and your unwillingness to give her any of your extra. He wants nothing more than to pit us all against each other. Because he fears how powerful we are together, of one mind. Stop letting the enemy critique your sister. Stand up for her. Take her repentant hand and help lift her up off the floor. Give her grace. You have been given enough to spare.

Today I'll try to be a little better than I was yesterday.

I'll love my sisters a little bit harder.

And throw grace around a little wilder.

DISTRACTION

I can get distracted by the silliest things.

Instead of fulfilling my purpose or doing the things that I know God is telling me to do, I do other stuff. I can be distracted by shiny, sparkly, frivolous things. If it glitters, it has my attention. I can easily fall into an HGTV coma as I watch forty-three couples search for the home of their dreams and narrow it down to a choice of three, followed by eighteen house flips where I must see the finished outcome. Meanwhile the dust on my entertainment center is thick enough to write messages in. Which would be the only way for my family to reach me since I'm certainly not communicating with them, other than to ask randomly as they walk by if they think we should paint the living room. I can get sucked into a *Netflix* series and lose actual days, mentally living the lives of the characters on screen, while I waste away the days I've been given here. My cell phone is another trap altogether. Have fourteen free seconds of mental space? I better jump on social media and watch a speed-enhanced video of someone making some delicious dish, which I will likely not take the time to make for my own family, because I'm too busy.

However, more often than not I'm distracted by good things, by spiritual things. If I know I need to spend time in the Lord's presence, I will convince myself that I just need to clean up my email inbox first. This leads me to a daily devotional, which leads me to an email from the online Bible study I'm doing, which leads me to *Amazon* to check out

the new book by the author featured in said online Bible study. Which leads me to that Lysa Terkeurst book I've been meaning to get. Which leads me to a line at the bottom of the screen that says, "Customers who bought this item also bought..." And now I'm staring at a whole plethora of Lysa-esque Christian authors and I need to read them all *right now!* If I somehow manage to escape from *Amazon*, I continue reading through my emails. I answer simple questions from coworkers; I jot down important dates on my calendar. God wouldn't want me to miss the Bible study dinner with the ladies from church, right?

ME: I wonder if I still have that recipe for buffalo chicken dip.

I land on an article in my inbox that I can knock out in a few minutes. It will be a quick read and I can take it off my to-do list. But then at the bottom is a link to another article titled, "10 Things You Didn't Know about the Ten Commandments." Well, I am a sucker for a numbered list and my curiosity is piqued. So I open the article and begin reading and notice links to several other articles at the bottom of the screen with titles like:

"7 Unhealthy Habits of a Church Mom"

ME: I'm a mom, and I take my kids to church. Am I doing something unhealthy? I should definitely read this. I mean, I don't want to screw up my kids!

"8 Things that Will Make Your Marriage Christ-Centered"

ME: I can think of a few right off the top of my head, but what are the others? Is my marriage okay? Maybe I should just check this out really quick and make sure I'm doing all eight things.

The list goes on and on, and all the things I'm reading seem like things I *need* to know to lead a better Christian life.

Before I realize what has happened, hours have passed and I have fallen down the rabbit hole of distraction and I didn't even see the hole because it was covered in Christianity, and masked with leafy foliage that looked like things that God would *want* me to spend my time on. And they are. But not if it means my time or my relationship with him is replaced with these things instead.

The enemy knows that I am susceptible to these distractions because he knows I love the Lord and want to read all about him. And the enemy will use these things to keep me reading *about* the Lord instead of talking *to him*. The enemy would rather I have nothing to do with God at all, but he also knows that's not the way I roll, so he does the next best thing: he tries to use my hunger for the things of God against me.

I love nothing more than to curl up with a stack of Lysa Terkeurst, Jen Hatmaker, and Rachel Hollis. I feel like these ladies are my long-lost sisters and best friends. And do not sit me in front of a video of Joyce Meyer, Beth Moore, or, heaven help me, Lisa Bevere. They light my soul on fire like no other and I literally transform into a "girl with a sword." I could watch these Godly women preach for hours on end, and there is nothing wrong with this. I cut my Christian teeth on Beth Moore (okay, not literally, I don't bite, and even if I did, I certainly would not bite Miss Beth).

But the bottom line is: these women cannot be my God.

They cannot replace my time in the Word. They cannot replace my time with my Heavenly Father. How good would your relationship with your best friend be if you just listened to your other girlfriends talk *about* her, but you never made time to sit and visit with her yourself? You would know the facts about what's going on in her life. You might have a superficial picture of how she's doing and what she's going through. But it would be one-sided. You wouldn't share your personal struggles and ask your friends to pass it along to her. If you're having a crap day you call, or text, or email, or Snapchat your best friend. Maybe you send word via carrier pigeon, or owl mail; it doesn't matter. You communicate directly with her. You lay out your frustrations and despair and you listen to her advice and her consoling voice that's always there when you need it. And you feel better.

It is no different with God. He doesn't want to *only* hear you talk *about* him. He desires for you to talk *to* him. And he doesn't want you to *only* hear about his love for you from other people; he wants you to intimately know it and feel it, directly from him.

Ladies, you don't have to finish your work, or your laundry, or get yourself looking pretty and in your perfect spiritual Zen pose to talk to God. It's not like he finishes up running the universe before he makes time to talk to you; he's just there, waiting for you.

ME: I did it again, didn't I? I got super sidetracked when we had an appointment to hang. I'm so freakin' sorry. I know I said I wasn't going to do this again, and here we are…uugghhh.

GOD: It's okay. I waited for you.

ME: I just get carried away with *one more thing* I need to do. I know I was going to meet you earlier, but that Lisa Bevere video, I mean, c'mon. Am I right?

GOD: <*smiles proudly*> I made her a firecracker.

ME: I'm so glad you're still available and always make time for me.

GOD: I never left. I rode with you to work. I went with you to your big meeting. I had lunch with you. I read your emails. I watched videos with you.

ME: Well, I hope you wore your seatbelt, because I was running a little late this morning and I might have been a teensy bit irritated about it, and that might have carried on throughout THE. ENTIRE. DAY.

GOD: I noticed you slowed down and let in the driver who was having a hard time merging into traffic. Then you smiled and waved at her.

ME: <*scrunches brow*>

GOD: You saw her, and you let her in.

ME: That's the part you saw? Not my bad attitude?

GOD: Yep.

ME: Well, that puts my petty problems in perspective.

GOD: I know you had a hard day. Do you want to talk about it?

ME: Just knowing you were there all day somehow makes it all feel okay now.

GOD: I will never leave your side.

Taylor, Whitney, and Dolly Make a Joyful Noise

You should have joy in your life, things that make you sigh and smile and fill you with instant contentment. Find joy. Choose joy. Write joy down. Eat an Almond Joy, whatever it takes to get joy inside of you. Memorize joy, so when your darkest days come (and they will for everyone) we can grasp those joys and remember them and cling to them like a life raft.

Here are a few things that bring me joy.

1. My offspring

 This seems like an obvious no-brainer, but it is as real and true as it gets. I'm captivated watching my kids huddle together, watching something funny on their "mobile-mind-control devices," teasing one another and expelling noxious bodily gases directly onto one another. I was raised as an only child, and I swear I will never fully understand this aspect of the sibling relationship. Watching them like this makes my mind flash back to when they were all small, little people, huddled together on the couch the same way, watching cartoons. With footy pajamas, sippy cups, Hot Wheel cars, and baby dolls. It was so easy back then to take those moments for granted, thinking I had all the

time in the world to watch them. So I went about my other tasks rather than absorbing the moment.

These moments also make me picture the future taller, bigger people they will be. I can imagine Christmas gatherings where they will leave their respective spouses and children in the kitchen and will once again huddle together on the couch to watch something funny, and torment one another the way only siblings can. I look at them and I marvel at the fact that I made humans. And not just any humans, ones who I actually want to hang out with. Humans who are funny, smart, and unique... I did that! Well, okay, so God knitted them together, but I cooked them inside my womb-oven, and that counts for something. Whoever said that kids are pieces of your heart walking around outside of your body was absolutely right.

When I watch them in these moments my heart quickens, because it recognizes the pieces of itself sitting there out in the world.

GOD: Now you see how I feel when you are close to me. When I see you interact with my other children.

ME: I don't think I could have fully understood your love for me until I loved these people I made...er, I mean...we made. You did all that behind the scenes, knitting together work. I just waddled around eating everything I could reach.

GOD: I chose you specifically to be their mother.

ME: Well, that's a lot of responsibility. I really do try every single day not to screw this up. Admittedly some days are better than others.

GOD: I don't expect you to be perfect. I expect you to show them my Son.

ME: That seems like a lofty task. I mean, I'm not in ministry or anything. I go to church, sure, but mostly I just go to work, come home, make dinner, do laundry...

GOD: You are enough. I designed you to be enough, just exactly as you are. I left the Holy Spirit with you. Your kids see it and feel it whenever you are there with them. Just keep being there. I'll take care of the rest. Relax. I've got you…and them.

ME: They just mean so much to me, I can't even imagine the pain of losing one of them.

GOD: I know *exactly* what you mean.

ME: It's just terrifying, you know? I've made many mistakes in my life and learned a lot, and I just want to spare them from having to learn things the hard way. They have so much potential; I can see it! I just need to keep them on the right path and keep guiding and leading them, but sometimes the weight of that responsibility feels like an anvil on my back. What if I totally mess them up?

GOD: You are not messing up anything. Just trust me.

ME: Okaaaay. I just need to know they're going to be okay. *<ever so slightly loosens the emotional and mental control-freak white-knuckle mom-grip on offspring>*

GOD: Your kids will be okay. They belong to me. I want their hearts, but I want them to *want me*. I want *them* to *seek me*. I'll give them space to figure it out. I've got them. Don't worry. My plans for them are good. Thank you for trusting me with them. Wherever they are, whatever season they are in, I *know* who they are going to become. So I will allow them to make the mistakes that will get them there. You, my girl, need to allow them also. I've got them. Just like I've got *you*.

ME: *<exhales>*

2. My bed

I know, it sounds stupid, but just hang with me. It's not even that I love to sleep, which I do, very much, but that's not it. I love how I *feel* when I'm tucked in my bed. I love my beautiful bedding, my pretty soft sheets, and my heavy comforter. Before

you go offtrack rolling your eyes and envisioning my premium down comforter and high-end, stylish accent pillows, just stop. This is not expensive stuff we're talking about here; this is Walmart-created joy and you, my sister on a budget, can afford and experience this kind of joy as well. It is both pretty and simple and perfectly suits me. Looking at my bed all made up in the morning with the sunlight streaming in the window is a simple pleasure that makes me smile. I adore snuggling down into freshly washed sheets and breathing in the clean, perfect goodness. I sigh and I smile a big goofy grin, and in that moment all seems right with the world. It's like Jesus himself came down from on high, tucked me in tightly, and kissed my forehead. Peaceful bliss. And Heaven help me…when my husband snuggles up with me, underneath all that warm, cozy comforter goodness, I could seriously die happy right there! Until he immediately falls asleep (which he is irritatingly efficient at) and begins to snore….then the magic dies. A slow, painful death that sounds eerily like a freight train rumbling down the tracks, but I digress. Don't forget to notice those little things that make your heart light up. Take them in and spend time with them. I promise you won't get to the end of your life and regret how much happiness you let seep inside of you. It is not time wasted to take a moment and indulge in whatever your own little thing is that brings you joy.

ME: My bed, geez, that's not exactly spiritually earth-shattering. I'm definitely gonna change lives and draw women to the Kingdom with that one. *<insert eye-roll here>*

GOD: It's okay to find joy in small comforts. I created you to be fulfilled.

ME: It makes me sound like I just want to stay in bed and sleep all day. Not that the idea hasn't crossed my mind, but it's not exactly the impression I want to convey to people. Don't

even get me started on how *boring* this makes me sound! Good gracious, some women are rock climbing and skydiving and I'm over here, self-indulging in a poly-cotton cocoon. I need to go out and get a life immediately. I need to start some sort of activity or interesting hobby, maybe something *dangerous*, something involving a helmet…ooohh, maybe roller derby.

GOD: I like it when you snuggle into bed.

ME: Really? But…why?

GOD: Because you're close to me. You talk to me there.

ME: Oh…

GOD: You are content there. Your mind is at ease. You aren't worrying about things that aren't yours to worry about. You aren't fretting and trying to control things that aren't your burdens to carry. You sink into your safe place and you just say, "Thank you," to me, over and over.

ME: I don't run off at the mouth as much when I'm falling asleep.

GOD: Well, I didn't want to point that out, but since you mention it…you do talk less when you rest in my presence.

ME: Hence, I listen more, since my mouth is moving less.

GOD: I've whispered many promises over you while you were a captive audience. Watching you sleep makes me smile.

ME: It never occurred to me that my sleeping would bring *you* joy.

GOD: Don't you remember standing over all those cribs, watching your babies' chests rise and fall with each breath they took?

ME: I marveled at what I had made and how perfect they seemed to be sleeping soundly. I thought my heart would explode with love for them. All I wanted was to protect each one of them.

GOD: Exactly how I feel.

3. Music and love songs

 If there is one vehicle God uses to speak directly to me, it is music. This is a weird anomaly to me, because I have no musical talent or ability, like AT ALL. I'm a word nerd. I love reading, writing, talking. I love saying a fun word over and over. I like learning the official word for something random, some object I've always called a doohickey or a thingamabob. I love words on signs, tee-shirts, and throw pillows. I am completely drawn in by words of affirmation by those I love, and I'm a complete sucker for a pet name. If my husband calls me "darlin'" or "babe," just sit back and watch me melt into a puddle of double X chromosome right before your very eyes.

 But for some reason, the Lord doesn't talk to me through the written word alone; he adds a melody to the message. I listen to a lot of Christian music, and the Lord has spoken to my heart plenty of times by drowning me in the Holy Spirit during a worship service at church, or while jamming to *K-Love* on the radio in my car. But one time he truly pulled me out of myself and made me hear HIM as plainly as if he had grabbed my face within his hands and looked full into my eyes and spoke the words right to my astonished face. Surprisingly this did not occur while I was sitting in a pew or jamming to Mandisa or any of my other favorite Christian artists. The Lord talked to me while I was listening to regular secular music.

 Please allow me to pause for a moment to make a point here. There is nothing wrong with being a Christian and listening to all types of music. In fact, so much great music is made up of love songs and I'm madly in love with my Savior, so it's easy for me to flip a lyric and change the perspective so I'm now praising my Lord while I jam to my favorite country or pop artist. While we're talking music, I feel that I must note that I am a serious Taylor Swift fan and dancing around and belting out a TS hit is right up there on my list of things that bring me joy. I mean

seriously, the girl has some wicked talent. If I possessed one ounce of her musical skill and ability, I would turn all my life's drama into clever lyrics with a catchy hook and make millions. And there may or may not be a few boys in my past whose antics would be spotlighted in my hypothetical pop anthem. TS isn't afraid to be vulnerable and lay out for the entire world both the hurts and the triumphs she's experienced. I have mad respect for that. Side note: Fair warning, if I ever get the privilege of meeting Taylor in person, I will likely become a complete blubbering fan girl. I'm just sayin'.

One day I had a musical epiphany that left me awestruck and changed the trajectory of my life forever.

It was as clear as day to me that the Lord of the Universe had just taken the time to talk directly to me, and not only that—he persistently poked at my subconscious until he had my full attention. It was a genuine "Godstop" moment, as Beth Moore would say, and it was my first one ever. This moment has stayed with me for many years and the memory of that day remains poignant. Which says a lot for me, because my memory is not awesome.

Let me set the scene for you. I was sitting curled up on the sofa in my bedroom working on a Bible study workbook. It was one of my first Beth Moore Bible studies and I was super serious about reading every assigned scripture and filling in every single blank. I was bound and determined to earn favor with God and vicariously from my new best friend Beth Moore as well, by being the best Bible study student there ever was.

Bless my heart.

In all honesty I secretly wanted to lord over the other ladies in my Bible study group the fact that my workbook was complete and perfect in all its *holiness*. My desire was to proclaim the following week:

"Gosh, I sure struggled getting all this done while working full time, taking care of all my young children, making my family homemade healthy meals, and keeping my house in order. Whew! Oh, and by the way, did anyone besides me get a chance to get a head start on the reading for next week? Sooo good!"

Seriously my self-righteousness was gross! Totally out of control, but that's a story for another day. I was not tolerating any interruptions. The irony is not lost on me that while I was absorbed in learning more about the Word of God, I would likely have verbally thrashed any of my children who had come into the room needing something during my Bible study time. Although, to be fair, they likely would have walked right past their father to come ask me for whatever they needed. *Whyyy* do they do that?

In a nearby room I could hear music playing. It was rather loud for my taste, but hey, I was a Super-Christian right? So I was tolerant and would choose to be patient and persevere, pushing through my study time. So I was more than a little perturbed with myself when my mind kept pulling me in the direction of the music in the adjoining room.

I tried not to listen to it.

I tried to block it out.

But I kept hearing, or rather *sensing* the word "listen." I was diligently reading an excerpt from Isaiah 54 and carefully writing each word from verse 10 into my study guide workbook.

They were *just words* to me, about mountains and hills.

Finally the pull to listen to the song playing in the background became overwhelming. I stopped writing and I'm certain that I rolled my eyes and sighed with annoyance and frustration. I turned my ears toward the sound and heard the heart-aching tones of Whitney Houston belting out "I Will Always Love You." Suddenly the words I had been writing moments earlier that were *just words* now seemed to literally jump off the page at me.

My face flushed, my stomach flipped, my mind opened wide with understanding like I'd never known, and I *really* heard what the Lord was trying to tell me.

Though the mountains be shaken, and the hills be removed, yet my unfailing love for you will not be shaken, nor my covenant of peace be removed. Says the Lord who has compassion on you (Isaiah 54:10, NIV).

I felt the warm flooding of the Holy Spirit and God's specific message just for me.

I will always love you…no matter what.

The Lord persisted and pursued me until he got my *full* attention, *just* to tell me he loves me, and that nothing could ever change that.

He didn't wait until I was a perfect Christian, because he knew I never would be. He didn't even wait until I finished Miss Beth's homework assignment. He just stopped me right where I was because he was so overwhelmed with love for me that he couldn't contain it and had to let me know.

I've often wondered if it would have made any difference if Whitney or Dolly had sung this love song from God to me. It probably would have had the same impact either way; both versions of the song give me chills to this day. Every single time I hear the notes of that song begin I am reminded of my Heavenly Father's complete adoration of me that is never ending. Nothing in this world brings me greater joy than feeling fully loved by God. He craved my attention that day and he pursued me until he had it.

If that's not a true-love story, girl, then I don't know what is.

ME: Those words you spoke to me all those years ago started this journey to where I am today, sitting here writing these words.

GOD: I told you all along I had plans for you, and that they were good.

ME: I kept that message of love you gave me tucked inside for a very long time. There were some difficult days along the way that I wasn't sure I entirely believed it, but I held on to the sliver of hope that the "no matter what" part of your love for me really was true.

GOD: My love for you never faltered. It was there from the very beginning when I made you, and it will be there at the very end of your time here, when you come to live with me.

ME: I felt you in such a real way that day that Whitney sang those words. I felt it like I've never felt anything else. It was such a strong and overwhelming feeling, and yet there were times later that I forgot it. How could that be? How could I forget?

GOD: It's okay. I was still there. I didn't go away.

ME: You just kept pursuing me. When I turned my back on you and insisted on going off and doing things my own way, you kept coming after me. I'm ashamed of how I acted in those moments that I forgot.

GOD: Nothing you could do would ever make me abandon you. You are my daughter and you belong to me. No matter where you are. I will *always* come for you.

ME: That is astounding and honestly a little hard for me to grasp.

GOD: That's because it's a love you can't fully understand here. But you will.

ME: It's so cool that you talk to me like this and you straight up tell me you'll love me forever, no matter what.

GOD: I want to talk to all my daughters just like this, so they know how much I love them.

ME: That's why you kept nagging...um...I mean, gently prompting me to share our conversations.

GOD: I don't nag. You just don't always listen the first time.

ME: I'll give you that one.

GOD: But, yes, I want your sisters to have the same relationship with me that you do. I love them more than they can ever know. I will never stop chasing them.

ME: And you want me to tell them so they know they can talk to you in the same way that we talk, and that you want to tell them yourself, "I love you."

GOD: Yes!

NAME THAT TUNE

I love to sing. Not for an audience, but rather just belting along with songs on the radio in the car. My best stress-relieving method is cruising around with the windows down, screaming along with my current girl rocker of choice. While I'm sure these are outstanding vocal feats, acoustically my best performances are in the shower. I love nothing more than to shampoo my hair while wailing out a hairband love song or shaving my legs while I rap. My daughter and I discovered one Sunday afternoon that the best place to hear a killer sing-along music mash-up is at Waffle House. We carb loaded on hash browns, bacon, specialty waffles, and Vanilla Ice. This is the stuff of real-life people. I generously tipped our waitress for enduring our vocal performance for an hour and a half.

Sometimes I can hear a song and immediately get sucked in by the hook. It's catchy and I deem it my new all-time-favorite-song-in-the-history-of-songs-ever. I play it on repeat until even I'm sick to death of it. Other times I might hear a new song by one of my favorite artists and my expectations are high, but I don't love it right away. However, I love the artist, so after hearing it several times and being familiar with the voice singing it, I start to *really* listen and it grows on me. It slowly becomes one of the favorites on my playlist, and before you know it I'm singing right along to every single word.

I secretly want to be a rock star. In fact, when I was a little girl I wanted to *be* Jem, from Jem and the Holograms, when I grew up, pink hair and all. My five-year-old self was also convinced that I was going to

marry Michael Jackson and live happily ever after singing "PYT" to millions of adoring fans. So in a nutshell I was going to be a cartoon singing sensation whose husband was the king of pop. Adorable and delusional, that pretty much sums up my childhood.

There is one tiny hiccup in my fictitious, wishful-thinking cover-band singing career. I don't always sing the right lyrics. That's probably understating the problem. MOST of the time…I flat out sing the *wrong* lyrics. Once I hear a lyric and begin singing it, wrong or right, that lyric becomes solidified and true to me.

Even if it's completely incorrect.

Even if once you take the lyric out of the song and use it in a sentence, it makes no sense at all.

Doesn't matter. I've sang it and I'm committed. This is now the lyric.

Even after the correct lyric has been explained to me, my mind is too stubborn to accept the fact that it could possibly be anything different. My ears just cannot hear the correct words because my brain refuses to change what I believe the artist is saying to me.

Let me give you an example. Edwin McCain sang a beautiful song called "I'll Be," and one of the lines in the chorus is "I'll be the greatest fan of your life" (or so I'm told). However, *I* sing this lyric as "I'll be the greatest event of your life." Originally I thought wholeheartedly that this was the actual lyric. Eventually someone in my family stopped the song and looked at me and said, "What did you just sing?" So I told them confidently, "I'll be the greatest event of your life… What?" At this point they informed me that I was singing the song wrong. To which I strongly protested. They even tried to explain how illogical and egotistical it was for someone singing a love song to tell their significant other they would be the greatest *event* of their life. What kind of a jerk says that to a girl?

This was a time before you could whip out your cell phone and prove how right you are within seconds. So I continued my lyrical stance until we could get to a CD with the lyrics printed inside the case. I was eventually proven wrong on paper and shown in black and white that I was singing the incorrect words. The song was even played for me so I could

fully grasp the error of my ways and take corrective action. But no matter how many times the CD was paused and played on repeat I simply could not hear the correct words. It was too ingrained in my brain to sing it the way I always had. Even if it was illogical, it was familiar to me.

That's how the enemy gets us all twisted up with wrong words and wrong thinking, by whispering lies to us so often they become familiar. What we need to remember is that within this famiLIARity is the word "liar." Just because the enemy has lied to you so many times, that it sounds familiar to you, it does not mean that it becomes truth.

What is your messed-up lyric? The one that the enemy taught you to sing.

He's done it to all of us.

He's slipped in a wrong lyric to each and every one of us, and we've sang it enough that it becomes our false truth.

He has a way of whispering into our mind, things that are incorrect according to the Word of God, but it has a spin to it that sounds *sort of* right. It's confusing, but not outright wrong, and sometimes we believe it rather than trying to untangle the truth from it. Eve had the same problem when the serpent asked, "Really? *None* of the of the fruit in the garden? God says you mustn't eat *any* of it?" (Genesis 3:1, TLB). What the serpent was telling her sounded *right enough* that she faltered, and that gave him an opening to convince her of an outright lie that ended up being extremely destructive.

I'm betting he's spun a lyric to you that sounds something like this:

You're a good mom, but you're not as good as...
You may be married, but your husband would love you more if you...
If you had a bigger house, all the kids would get along better...
You're divorced, no one else will ever want you...
If you made more money, you would be happier...
I can't believe you made this mistake...again...you're hopeless, why even try...
It's harmless flirting...

If you sing the lyric wrong enough times, you start to sing it confidently, even if it doesn't make sense. Ladies, if ANYTHING you are singing on repeat in your head does not fall neatly under this truth—*you are a royal daughter of the king, loved beyond measure, and drowning in grace*—then it is not the right lyric.

It is a lie.

Shut down the Spotify and stop singing it.

When you talk with God, he will counter every single wrong line that you've been singing with his truth. He will sing you a new song, and the best part is…it's all about you.

ME: I've believed some far-out nonsense over the years.

GOD: But now you believe what I say about you.

ME: I still hear those lies sometimes, like…*I'm not good enough.*

GOD: You've spent enough time with me that you recognize a lie when you hear one.

ME: It's just hard sometimes to shut it down. The enemy is persistent about throwing lies directly at my face.

GOD: Do you believe who I say you are?

ME: Absolutely.

GOD: Then he has no power over you.

ME: But seriously…how am I supposed to tell these women not to believe the wrong things that they've been letting the enemy whisper over them on repeat, when he still gets in my head sometimes, too?

GOD: You're already doing it.

ME: I am?

GOD: You're talking to *me* about it. That's all I want all my daughters to do.

ME: Ya know, it would be a lot simpler if the enemy would just leave me alone.

GOD: He won't do that. Not if you pose a threat.

ME: Wait…hold up. *I'm* a threat to *him*?

GOD: He wants to keep my daughters in chains. He wants to keep

them quiet. He wants to destroy them and any relationship they have with me.

ME: So he wants to keep *me* quiet, too, by convincing me that I can't do what you've called me to do. So that I will quit.

GOD: He knows I have equipped you with everything you need to accomplish my purpose for you. So the only way to stop it is to convince you that you cannot succeed.

ME: And the only way to defeat his scheming, annoying liar face is to *know* you and *know* how much you love me and how you uniquely made me to do what you've called me to do.

GOD: Correct. I need all your sisters to know this as well. I specially made each of their hearts and I put passions inside of them and gave them the skills and abilities necessary to complete the assignment I have placed inside each one of them.

Sister, if you are reading this, even if you didn't buy the book but instead picked it up on a shelf and flipped through it to see if it was interesting enough to spend your money on, it was no accident. You are right where you are supposed to be. If you bought the book and it sat on the pile of books you haven't gotten around to reading for the past eight months, you are right where you're supposed to be. You are hearing God tell you exactly what He wants to tell you at this exact moment in your life. That thing you're good at, the one that lights you up from way deep down inside to way out to your fingertips, to the ends of every single hair on your head. That *thing* is no accident. God gives us girls lots of freebies. Grace, unconditional love, forgiveness. But he expects something from us, too. He expects us to use that *thing* that he put inside of us that brings attention to him and his Kingdom. He expects us to show his love he gave us freely to those around us. He expects us to introduce him to those who don't know him yet. And whatever your *thing* is, I'm willing to bet that it will put people who do not know him in your path. If you do what he's put you here to do…they will know him. And it all starts with a relationship and a conversation with the one who knitted your *thing* into the fabric

of who you are. So stop singing the wrong lyrics over yourself and start singing his promises over your life.

You are a daughter of the Most High.

You are valued more than diamonds.

You have an assignment that only YOU can do.

You have inside of you EVERYTHING you need to accomplish it.

You are royalty.

You are loved.

You got this.

HE WEARS BLUE

People come into our churches broken, hurting, seeking, needing something that sometimes they can't even put into words. Pastors, elders, worship leaders, and prayer teams are there to lift up these people and give them hope, a shoulder to lean on, an ear to listen. But the responsibility does not lie solely with the folks we face forward and look at during service. These hurting people who come into our churches are *our* responsibility as well.

My husband is an introvert. In every sense of the word. He is unique in that he isn't an introvert *all* the time. He works in law enforcement, and when he is at work he is bold and action driven. He can raise his voice above the noise and bring order to chaos in a crowd. But at home, when he takes off the blue uniform that he wears to work every day, he is soft spoken and prefers solitude to large crowds. He is not comfortable introducing himself to people and making small talk. It feels awkward. But God doesn't care about any of that. He created my husband with specific character traits that HE intends to use for his glory whether he is wearing blue or not.

I don't know how it is for any of you, but the part of church where the pastor encourages you to turn to someone you don't know and welcome them to church is pure torture for the introvert. We ladies will find reasons to search frantically in our purses for tissues or gum. We fiddle with our cell phones, suddenly remembering that we need to set them to silent.

We focus intently on conversations with the person we rode in the same car with to get to church in the first place. We shuffle around filled with anxiety for two point five minutes until we can finally take our seats and enfold ourselves back inside our safety bubbles.

My husband and I are very similar in these situations, although he can fake his way through it much better than I can. One Sunday at church I looked toward my introverted partner during handshake time, and he wasn't there. I was initially panicked, as this meant I was instead looking at a stranger who was in his place and I was thrust into a *good-morning-glad-you're-here* mantra as I simultaneously wondered how my shy husband had dematerialized before me. As I glanced around the room over the shoulders of fresh-powder-faced little old ladies who hugged me *good morning dear*, I spotted him. He was bent over talking to a young man with his hand squarely on the man's shoulder, looking into his face, listening and nodding. I thought to myself, *It must be someone he knows.* I glanced at him quizzically as he returned to his seat, and even though it nearly killed me (because I MUST know everything that is going on), I kept quiet until service was over. Once we were safely back in the car, I asked him, "Who was the man you were talking to at the beginning of service?"

He casually responded, "I don't know."

What?

Then he just stopped talking, as if he hadn't just done something entirely out of character that was obviously going to require a conversation later. If it were me who had operated so entirely out of my comfort zone, I would have already talked his ear off, telling him all about the details and nuances of the conversation. So naturally I pressed further. "Well, what's his name?" He said that he didn't know his name. He had simply noticed that the young man was visibly upset, sitting with his face and head cradled in his hands, and he appeared to be crying. He took the opportunity during the morning greeting to go across the room to this man and ask him if everything was okay. The man explained to him that his sister had been in a horrific car accident and that she was pregnant,

and as a result of the accident she had lost her baby and her own life still hung in the balance.

A horrific accident indeed.

My husband deeply understood this man's anguish, because that awful day of the accident...he had been wearing blue.

This accident was one of many that my sweet husband, the police officer, had responded to.

The day of the accident, he had stood over the wreckage and seen this soon-to-be mother, this sister, this daughter. His eyes had looked upon the mangled steel that used to be her car. His ears had heard the wailing siren of the ambulance as it rushed her to the hospital, desperately trying to save her and her baby. He had talked to witnesses and asked each in turn to tell him again the story of what they had seen. He had diagramed the angle of the vehicles, the speed at which they were traveling, the condition of the weather at the time of the crash. His hands had written the report, detailing everything that had happened.

And then he came home.

He had dinner, and watched TV, and responded to questions like, "How was your day?" with platitudes like, "Okay, just the usual."

None of the details of the trauma he had witnessed were evident or spoken of.

And yet he understood much more of this young man's story than the man himself did. But my husband didn't tell the grieving brother any of this. He didn't need to. That wasn't God's point. The point was that he understood. God moved an introvert and uniquely placed him in a position to truly understand another person's brokenness. This was no accident or coincidence. This was God putting his arms around a young man suffering, weeping, and heart broken and giving him comfort; he simply used my husband's arms to do so.

So often in our lifetimes we see, hear, or experience for ourselves things that fracture our minds or bodies. And why? Is God up there causing bad things to happen to us to teach us some cosmic lesson? No, of course not. We live in a broken world where *crappy* things happen all the

time. God doesn't cause it, but he does make sure that it isn't wasted. He heals the brokenhearted, then he uses that healed person to go out and heal another broken heart that was shattered under similar circumstances. It's like an elaborate game of chess, where God is moving his children around and placing them in the path of one another with intentionality.

Experience is the fuel of empathy.

What are some of the dark things you've experienced? Did it make you softer toward others who have walked the same path? God can use all of it. Just ask him to put *one* person in your path who you are uniquely positioned to understand. Then when they show up (because they will) take that opportunity to be the arms of God for them.

ME: I was so blown away after church that day. I don't know HOW he wasn't just bursting to tell me all about talking with that guy. I mean, it was so totally out of his character to do that.

GOD: He didn't spend a lot of time on the decision to move. I urged him, and he got up and went.

ME: But he goes out and he does these amazing things every day. He helps people. He sees things no one should see, and handles complex situations where humanity is at its worst. Then he comes home, like *just another day*, and carries on with life.

GOD: He does not see it as extraordinary.

ME: That's crazy! I would be all about how I caught bad guys, and drove fast, and helped those less fortunate all day long. I would probably apply for sainthood.

GOD: He is not wired the same as you.

ME: But he helps people, sometimes who are experiencing the worst day of their lives! Combine that with how many years he has done this and that's *thousands* of worst days! That's exceptional, even for someone humble.

GOD: I designed him with a specific assignment to protect and to serve.

ME: I know, and he's awesome at it, but he acts like it's just no big deal!

GOD: He is living out his purpose; it does not feel out of the ordinary to him. If feels like breathing.

ME: <*widens eyes as an epiphany occurs*> Ah, so if we would live out our purpose in you, things would feel more natural, without so much of the grind and hustle we put on all the stuff we try to do our own way.

GOD: I made you...and him, equipped with everything you need inside of you to do what you are assigned.

Each of us came pre-wired from our manufacturer to do what God created us to do. This doesn't mean you have to wear a uniform and carry a gun to work for the Kingdom. What God has created and called you to do isn't necessarily even related to how you get your paycheck, or whether you get a paycheck at all. Whether you stay at home and manage your house and family, or pack your briefcase and rock the boardroom, it doesn't make any difference. Your assignment could lie in what you do on Saturday afternoons that fuels your fire and stirs your soul. And if you don't know what that stirring is yet that's urging you toward your assignment, I know a guy you can talk to about it. He wants nothing more than to have a conversation with you and introduce you to those talents and giftings that make you uniquely qualified like *no one else on planet Earth*, to do precisely what he has already deemed you a perfect fit for.

Vulnerability Looks
Good on You

Have you ever been deeply betrayed by someone you love?
Me too.

It's devastating.

Can we just put *"The End"* here and be done with it?

I hesitated to share this story and the subsequent conversations that God and I had about it, because it didn't seem like something extraordinary that would make an impact on women. Just the opposite. In fact, it seemed very ordinary and "common." Statistics are high on extramarital affairs and divorce. They don't even raise eyebrows anymore. I complained to God that there were entire books written about affairs and how people have gotten through them, and so on. Surely there wasn't any need to revisit the issue with my story of yet another woman who lived through a betrayal at the hands of someone they loved and trusted. Cue the sad music, I've heard this one before.

ME: This story is like a broken record. It's not like I lived through some crazy tragedy—it was an affair; it happens to women all the time.

GOD: So it's common.

ME: Yes! Exactly! It sucked, and it broke my heart, but the experience isn't unique to *me.* I don't have some miraculous perspective.

GOD: So what you're saying is that a lot of your sisters have probably experienced something similar and can relate?

ME: Well…probably. Where are you going with this?

GOD: Did you learn anything from it?

ME: Of course. I made some terrible choices back then and I regret them to this day.

GOD: Tell them about *that* part.

ME: What!? Tell them how *I* screwed up?

GOD: Exactly.

ME: But…that leaves me vulnerable.

GOD: Yes, it does.

ME: I don't know if I can do what you're asking.

GOD: Yes, you can. You can do anything I ask you. I'm right here.

I would like to be able to tell you that when I was neck deep in bad decisions it was because I wasn't yet a Christian. I wasn't saved and didn't know the Lord. But that would be a lie, albeit one that would make me feel better about my mistakes, but a lie, nonetheless. It would be convenient and comfortable for me to chalk up my sin as an "I didn't know any better" situation and wrap the whole ugly mess up in pretty paper and slap a shiny bow on top. But that would be a disservice to you. If I led you to believe that only *unsaved* people wallowed in the pit of sin, then you would feel "safe" from falling into such a situation yourself. But instead I am here to tell you that you are NOT safe. You, sweet sister, are in danger. Real and present danger. The enemy is seeking to kill and destroy you, and he would like nothing better than to light a match under your weaknesses and watch you set yourself on fire and slowly burn to death. I am not exaggerating. However, don't be fooled into thinking that he's always full of drama and flair. He isn't always bold, big, and fast with his tactics. He is sneaky, and subtle. And worst of all he is patient. He has had thousands of years to perfect his craft. He can plant a seed, light a spark, breathe a little lie, pour alcohol on an open wound, and then sit back, watching and waiting for you to slowly unravel. His end game is to

pull you from God and destroy you; it doesn't matter if it takes him five minutes or fifty years. He is patient and persistent.

When I committed adultery…

ME: <*stops after typing these four words and stares at computer screen for a very long time*>

ME: Nope. I can't do this. I can't write about this. I will just have to leave this part out. *No one needs to know about this part of my life.*

GOD: Why?

ME: Because it was a long time ago. It's over and done with and I don't want to think about it anymore.

GOD: I restored everything in your life. Just like I promised you I would. Talk about that.

ME: But the part that caused me to need the restoration in the first place is so shameful and awful. <*hides face in both hands*>

GOD: You already gave me the shame.

ME: Well, apparently, I kept a piece for later.

GOD: Give it to me.

ME: No. I need it.

GOD: <*waits*>

ME: If I don't hang on to some shame it's like I'm saying what I did is "okay," and it's not.

GOD: No, it is not okay. But chaining yourself to it is also not okay. Give it to me.

ME: <*swallows hard, feeling the oh so familiar lump in the throat and the heavy knot forming into a stomachache*>

GOD: <*waits*>

ME: <*opens clenched fists and hands shame over to God AGAIN, for the thousandth time*>

GOD: You do not need to keep saving these crumbs of shame. You asked me for my forgiveness, which I gave you, and my grace is still covering you.

ME: Exposing this feels dangerous and scary.

GOD: Who do you think is making you feel fear?

ME: I am. I'm freaking myself out.

GOD: Did I create you in a spirit of fear?

ME: No.

GOD: WHO is making you fearful?

ME: The enemy?

GOD: And why would he do that?

ME: To shut me up?

GOD: Yes.

ME: But embarrassing me and shaming me in front of everyone who might read this should be what he wants, right?

GOD: What he does *not* want is for anyone to heal after hearing your words.

ME: And what I have to say about my mistakes could make a difference?

GOD: You have a sister reading these words this very minute, someone who feels shattered. She needs you to tell her that she is okay. That I love her. *No matter what.* That there is a light at the other end of her darkness and her sin. And that I will use her mightily for my glory, even in her mess.

ME: That's a lot of risk to take to reach out to one woman.

GOD: One is all I need.

Forging on…

When I committed adultery I was already a "Christian." I had a relationship with Jesus. I went to church. I went to women's group. I went to Bible study group. I journaled. I prayed. I did all the right things.

Until I didn't.

Even as I was doing all the seemingly "right" things, I was still aching inside from a wound that never healed. A part of me that used to feel safe, secure, and normal before I was cheated on now felt open, gaping, hollow, and undone. No matter what boxes I checked on the Christian good-girl scoresheet, it didn't add up enough to fill the hole. But rather

than allowing God to slowly fill my empty places that had been carved out by infidelity, instead I tried to control the hurt and the healing by taking matters into my own hands. I tried lots of different types of filler to fix myself.

I tried shopping. That would work for a very brief amount of time, as the immediate high of something new and shiny felt good enough to lift my spirits. But that was so short lived it wasn't worth all the money I was spending for such fleeting relief. Not enough payoff.

I tried eating. This was also a quick and immediate satisfaction, to eat anything and everything I desired and in large quantities. Hello, buffet. It felt pretty satisfying in the moment, but then was quickly followed by disgust and self-loathing at how I felt and looked afterward. This was also not enough of a payoff to be a good solution.

Then I stumbled upon perfection. Hot Mess Express—now boarding. Now this was a surefire way to control my world and reestablish the normal and the predictable that I had lost after discovering the loyalty I thought had been present in my marriage was never there at all. I simply had to be perfect and ensure everyone around me was also perfect, and my firm footing would take hold once again and the world would right itself. Because that's why this happened to me in the first place, right? Because I wasn't a good enough wife, mother, and woman? I wasn't skinny enough, attentive enough, sexy enough? I didn't have enough "enough-ness" that keeps a husband faithful. Right?

Wrong.

This thinking was all wrong, but the enemy knows about my struggles with perfectionism and my insecurities when I don't measure up to the impossible standard that I set for myself. So he whispered imperfections to me and the perfectionism as my cure idea began to bloom. And keeping things perfect all the time felt great! Tidy house, well-behaved kids, balancing work, home, marriage, laundry, homemade dinners, story time, more laundry, perfect skin, shiny hair, shaved legs EVERY DAY, sunny disposition, Bible reading, quality time, date nights, sex, hobbies, volunteering… No problem.

Except that it was utterly exhausting, and instead of doing the important things well I was being mediocre at a thousand different things, and mediocre does not equal perfection. It became clear that this wasn't going to heal my brokenness, either. But it's not as if the enemy ran out tricks and gave up. Oh no, he had plenty of other ideas.

There is some obvious fallout from the discovery that you have been cheated on. One is right within that very sentence. Cheated. You've been "cheated." Cheated out of the expectation you had for the relationship and for your life. It's unfair. The scales of justice are completely lopsided and we long to right the wrongs done to us and put the weight of each side back into balance. Back to normal. In fact, when the affair to came to light I literally stomped my feet and flailed my fists in defiance of what I was hearing and trying to come to grips with. The unfairness of what had been done to me came bursting out of me like a toddler demanding to have their way.

How could this happen to me?

To ME?

This is not how any of this was supposed to go. This is not fair. I don't deserve this.

And a whisper came from the sidelines:

You poor thing.
How could he do this to you?
Who does he think he is?
You're a good person and you don't deserve this.
He should pay for what he's done to you.
Things will never be the same now.
You're broken.

And my victim mentality blossomed. The enemy is crafty. He knew if he could tie me down with chains of feeling sorry for myself, I would never rise above it and make good use of my sorrow. He didn't whisper anything to me that I wasn't already thinking; he simply reinforced my

negative self-pity until it was so loud and crashing within my mind that it was all I could hear.

Not only was I wallowing in my hurt feelings but I also became self-righteous.

I decided to forgive.

Sort of.

Anyone who has had to forgive someone very close to them knows that forgiveness often isn't a one and done deal. You don't say the words and wave a magic wand and the hurt disappears. You forgive that person repeatedly. Sometimes daily, sometimes many times a day. And I did this, for many years. And over the course of these years I was still living mentally as a self-righteous *victim* of adultery, forgiving my poor cheating husband day after day. Being the bigger person time and time again. I set myself up as a martyr. I felt superior to him. I was clearly a better person because I would *never* do the things that he had done to me. I was a more mature and spiritually elevated person. And I would continue to be better than him and continue forgiving his grave mistake, bless his heart.

I remember during this time I was doing a Beth Moore Bible study at church called "Breaking Free." It was all about breaking the strongholds in our lives that were holding us captive, so we could live truly free in Christ's love. Sounds good, right? Well, it would have been had I applied even one single solitary sentence of it to my own life. Nope. That's not what I did. I read every word from the perspective of my husband and how *his* strongholds had led *him* to infidelity, and *my goodness, how sad that he was in such bondage.* I wouldn't be caught dead in that position myself. I would never cheat on him. I would never be that type of person. I was better than that. Bless *my* heart. As I crossed my arms indignantly and prayed for my husband's bondage through the entire workbook, the enemy was taking all of this in and scheming.

Now I'm not comparing myself to Job here in any way, shape, or form. But you all know the story of Job. The enemy went to God and wanted to have a go at trying to derail Job because he was so loved and favored by God. He was sure he could get him to deny and curse God if he just did

enough bad things to him. Like really bad things. Like killing his children and destroying his home and everything he had worked his whole life for. Not to mention making him super sick and physically in pain with oozing sores. God was so confident in Job's loyalty to him that he told the enemy fine, he could go ahead and do whatever he wanted to test Job, so long as he didn't kill him. Because then Job would have just wound up in heaven with God and that would have defeated the purpose of what he was trying to prove, and then God wouldn't have been able to show his glory when it was all said and done. So long story short, God allowed the enemy to test Job and do really bad things to him. But Job never wavered away from God, and in the end God blessed Job with way more than he ever had before and more than he could have ever dreamed of, because he was faithful.

Oh, how I wish I could draw a perfect parallel between Job's story and my own. But that is not the case. I can't say for sure, but I can only imagine that my Pharisee-esque behavior was pretty dang annoying to God. He didn't like the Pharisees' holier than thou behavior back then and he didn't like it coming out of my mouth, either. In other words God still loved me, but he may not have liked me very much at that time. I imagine an exchange like the one the enemy and God worked out regarding Job occurred and the enemy went to God and said, "Hey, this girl has gone off the rails with this churchy talk. Let me take a stab at tempting her in this area, and let's see how it plays out. If nothing else, it may shut her up." And God being God, he could see the entire big picture of exactly how this whole thing would turn out. He loved me too much to leave me where I was, rocketing off on my own path of self-righteous destruction. So he let the enemy have his way.

Now let's pause there and add one more specific piece of fallout to the discovery of an affair.

Undesirability.

When I learned of the affair, one of the first things I felt was undesirable. In fact, I felt downright gross. One, because someone who had been intimately touching my body had, unbeknownst to me, also been

touching someone else's body with the same intimacy. With the same hands. It made me want to crawl out of my skin. The fact that he would choose to touch a different woman in this way made me feel unwanted, ugly, and unattractive. I deduced that if I wasn't desirable enough to keep him from straying, I clearly had something wrong with me physically. I obviously wasn't pretty enough, skinny enough, young enough for any man to ever be satisfied being with me exclusively.

Some of these thoughts were natural after being hurt in my marriage, in the way that I was hurt. Regardless of whether any of it is true or not, it's a knee-jerk reaction to think this way after you've been betrayed. With the right words from a good and trusted counselor, I could have eventually worked through these mentally damaging thoughts. But I didn't talk to a counselor about the undesirable struggle I was having. I didn't talk to anyone. I isolated myself in this area. Which is right where the enemy wanted me.

As I sat alone in my bedroom, the enemy sat down opposite me, crisscross applesauce and fed me apple after apple laced with lies.

You can make this right.
There is a way you can feel better.
You can do better than him.
He deserves this.
No one needs to know.
If no one else knows about it, no one will get hurt.
It's not a big deal.
People do this all the time.
You'll feel so much better once someone else wants you.

And I ate every single one.

Eventually I believed every lie that the enemy was feeding me. The empty, hurt place that I was longing to be filled with something, *anything* that would take the pain away, combined with the unfairness of the situation and the feeling of being undesirable, created the perfect storm.

I had an affair of my own in the hope that it would right a wrong and make me feel wanted and whole again.

And if I'm being perfectly honest, it did put a Band-Aid on it for a while. For a moment I felt the thrilling rush of being desired, wanted, and normal again. But as good as I felt in that moment, I knew it wasn't real. It was fake. It was all smoke and mirrors. None of it was going to last. It was all going to end, and the ending was going to be bad. I found a temporary relief for my hurting heart, but in exchange I traded it for a lifetime of shame and regret. I earned for myself one of those "if you could go back and change one thing about your life, what would it be?" moments. But unfortunately we don't get do-overs. And the choices we make are the ones we are stuck with for the rest of our lives. Good or bad. I made a bad one. An un-classy and ugly one. I wish I could tell a prettier story, a happy ending, perseverance pays off, faith wins in the end story. But that isn't my story to tell.

We got divorced.

I don't tell you any of what led up to my affair as a way of excusing my behavior. What I did was wrong, and it was a sin. And it was my choice. Plain and simple. There is no flowery or flattering way to dress it up. Something bad happened to me, and then I made a horrible choice as a means of dealing with it. The enemy didn't "make" me do anything. I have free will and I chose to do what I did. Did the enemy use my insecurity and weakness surrounding my broken heart to tempt me? I believe so. But I still had a choice. I could have chosen to be faithful. I could have chosen to be more like Job. I could have chosen to wait on God's healing. But I didn't. I chose the flesh, and I chose sin. And it backfired in a big way, leaving a lasting negative effect. And that lasting effect wasn't just on us as a couple; it most definitely carved up the hearts of our three kids as well. I hurt people. People I love. I hurt God. I hurt myself. All to ease a hurt that God could and would have healed if I would have turned it all over to him and waited on him to heal my broken heart in his timing.

Instead I did things my way. And I broke things even more than they were already broken.

So now what?

What do I do with all this leftover baggage from my past mistakes?

I use it.

I tell you all about how my life didn't ultimately end because of my sins. I eventually confessed my mistakes to God (he already knew about them anyway) and asked him to please forgive me. I repented and asked the Lord to make my heart brand new.

Fast-forward through a long and painful divorce, a three-year reconciliation, another devastating separation, a dark season of healing, redemption, a new heart, a new marriage to my current husband, and three more bonus kids. When I gave GOD all the broken pieces and surrendered to doing things his way, he restored me and blessed me more than I thought would ever be possible for me again.

There is nothing you can do that will make God turn his back on you. Absolutely nothing.

If you read my words and heed my warnings and it stops you in your tracks from making a mistake of your own that could damage your life, that's great! Praise God that he put these words in front of you at this exact season of your life. Write it down. Mark it. Remember it. Don't ever forget about the time when the Almighty Father loved you so much he halted you at a gate he refused to let you enter.

However, if you have already done some things that you think you can't come back from, I'm here to tell you, that is a lie. I wish with all that I have that I was standing in front of you right now with my hands on either side of your face and looking into your tear-filled eyes with an understanding that you and I share. I would look at you with compassion and speak our Father's message to you. You made a mistake, but YOU are NOT a mistake. You still have value and a purpose, and he still has work for you to do. You are going to be okay.

You are forgivable, you are loveable, you are special, and you are His. It's not too late to rewrite the ending to your story, which has somehow gone way off track. Maybe you're reading this and you're facing a heartache like what I've described. Maybe you've made a similar bad call that

has had a devastating ripple effect on your life, like mine did. Don't bury it and hide it away. God will use it and he has a plan to use you and all you've been through. He wastes nothing—not even the sin. It's time to talk to your Heavenly Father about it.

ME: Well, there it is, laid out for all to see. I gave you my broken heart, and you fixed it. I gave you my shame and sorrow, and you forgave me. Now I'm giving you my vulnerability and my words. I'm trusting you to take them and do something good with them.

GOD: I already have.

MARY, TEEN MOM

O ne Christmas, as I was sitting in church with my family, my per-
spective on the birth of our Savior took a sharp turn. I'd heard the
story a million times. I'd been awed by the idea of a momma giving birth
in the hay with no epidural or ice chips, but I'd also been complacent at
times, having heard the miracle story on repeat. I'd been pregnant with
all three of my kids during the Christmas season, one time being only
four days from giving birth as we celebrated around the tree. And in each
season of my life I'd looked at the Christmas story a little differently. Being
pregnant with my own babies made it easier to put myself in Mary's shoes
(or sandals?) and empathize with her struggles. She was carrying a great
responsibility within her body, and she did it while riding a considerable
distance on a donkey! There were days I couldn't get in and out of our
SUV. My seasons of carrying human life within me have passed, but still
a new perspective hit me that Christmas with the force of a dump truck.

My daughter Cassidy was the age of the Virgin Mary.

Theologians vary on the exact age that Mary conceived and gave birth
to Jesus, but all fell within the age range of my daughter at that time. As my
"little" girl and I sat at a Christmas concert, listening to songs retelling the
age-old story of the obedient Mary who was assigned one of the greatest
and most reputation-slamming tasks of all time, I looked at my daughter
and said, "Mary was your age when she was pregnant with Jesus."

And then I stopped dead in my tracks.

I *really* looked at my daughter and I saw her for the first time in a whole new light. It wasn't just the blue stage lights reflecting in her innocent eyes under her hoodie. I saw her as a woman, and a potential mother. I saw how beautiful and brave she is, and I saw Mary reflected in her face. I realized how truly incredible, astounding, and awe-dropping Mary's obedience was.

An angel appeared to her, like literally visible in front of her young face, and told her she was going to be pregnant. Also, what she was supposed to name this kid and that he's going to be a pretty big deal to the whole freakin' world. I mean, *come on!*

Mary's response is equally crazy to me. She's betrothed to her man Joseph at this point, so someone close to her—most likely her mama, her auntie, or her BFF—have explained what was expected physically of her after the "I do's" took place. It would be safe to assume that her first response to the angel Gabriel should be sheer panic, but it's not. Rather it's simply logistical: *How is this gonna go down, being that I'm a virgin and all?* He explained the basic concept to her and told her that her cuz, who was quite old, was going to have a baby as well—miracles all around! You get a miracle, and you get a miracle...

Not once during this exchange did she freak out, cry hysterically, or ask for time to think this over. Mary must know how this was going to look to her family, friends, and the entire community, not to mention her boyfriend/fiancé/boo. This was the modern-day equivalent of the angel Gabe asking modern teen mom Mary to post a nude baby bump pic on her *Instagram* page. The public humiliation would be far-reaching.

As a teen-mom myself a couple of decades ago, I know only a fraction of the shame and disappointment that accompanies the plus sign on that stick (and each of the three successive sticks I peed on because maybe my pee lied the first few times). In our current culture there is still some judgement placed on unwed mothers, although it is sometimes found to be more acceptable, not necessarily out of grace, but rather out of the sheer commonness of how often it happens. It occurs so frequently that it's become entertainment. Mary is the OG teen mom. They could revisit

Mary on later episodes to find that she ended up marrying her man, had some more kiddos, and her baby turned out to be wildly successful and influential to the whole world. Mic drop.

The Bible doesn't speak much on the hardship that pregnant teen Mary must surely have endured. Times were very different then, and although being a very young mother was common, doing so out of wedlock still carried the weight of public shame, not only to herself but also to her entire family and the family of the man she was promised to.

Looking at my little girl's face, I cannot imagine seeing her shoulders slump with the weight of others' condemnation. It breaks my heart. Then my heart aches for the girl Mary, who to me was still a girl, not yet a woman, and how courageous her young heart must have been. Once she understood how this miraculous pregnancy would happen, she didn't give any energy to anxiety. She just said, "Yes, I belong to God, so let's do this thing."

I want to be that woman.

I long to be so trusting in God that he gets my immediate yes to whatever he asks of me, regardless of how I fear being viewed by the world and by those closest to my heart. Because all that matters is who HE says I am, and how much HE loves me, and nothing HE could ever ask of me will alter that.

ME: Your timing never ceases to amaze me.

GOD: Oh?

ME: I started this piece about Mary several chapters ago, but then I put it aside.

GOD: Yes, I recall that.

ME: And I just happen to pick it back up right after I finish the previous chapter on vulnerability that I DID NOT want to share with the world. But you insisted.

GOD: Well, that is quite the coincidence.

ME: Really?

GOD: Did that last paragraph touch a nerve?

ME: You mean the one about wanting to be the woman who does whatever you ask of her without hesitation and without worrying what other people think about it?

GOD: And are you that woman?

ME: I'm trying to be.

GOD: I'm proud of you.

ME: This was supposed to be about Mary and how young she was, and maybe a twist on my own struggles as a young mother trying to figure things out.

GOD: I had other plans.

ME: You have a habit of that. Now it's become all about following through with what you ask me to do.

GOD: I want your yes.

ME: Sometimes it isn't easy to do what you ask, though, especially if I can't see the point of it.

GOD: That's how I know you are really trusting me.

ME: I suppose if it was an easy decision to give you my yes, then it wouldn't cost me anything.

GOD: That's correct. My assignments for you are not always comfortable.

ME: That is the understatement of the century! It's like you enjoy shoving me out of my comfort zone.

GOD: I love you too much to leave you right where you are. I have so much more for you.

ME: *<smiles>* Okay, I guess I can accept that, even though you hijacked my story.

GOD: *<returns smile>* You can have it back now.

Did you ever wonder how you can tell if God is telling you to do something? There are a couple of indicator lights that come on when the Lord wants your "yes."

If the thing you're pondering meets the following criteria, you might be a Jesusey-girl with an assignment:

1. It's scary.
2. It's big.

It's big and scary. Like a monster. Like a big, scary monster idea that God wants YOU to do.

Ta-da!

It doesn't have to be big like building an ark. If you're a shy person by nature and God asks you to tell the stranger at the bus stop that Jesus loves them, that is big and scary! Talking to a stranger is not a big calling like starting a ministry, and it seemingly doesn't change the world for the better. But it could change that one single person's entire life and you have no idea what God can do with the ripple effect of our obedience.

If you think about it, it makes sense that whatever God asks us to do would be big and scary, because if it was small and easy, then we would do it without hesitation and probably take credit for it ourselves. Where's the God in that? It must be big enough and uncomfortable enough that it stretches us and forces us to rely upon God to accomplish it. That is how his glory shines through.

I can tell you that no single solitary atom within my body wanted to write the last chapter. But God asked for my yes. So I did it. Oftentimes as my fingers typed my teeth were clenched and some serious fear crept in. I had a million excuses of my own why I didn't want to share that part of my story and lay bare all my heartache, humiliation, and disgrace. But don't even get me started on the things the enemy whispered to me to try to get me to stop. Which gave me even more reason to do it. Clearly if it is something the enemy wants to stop me from doing, it is something I should run toward with all that I have to give.

But the greatest part of my yes is that God was already on the other side of it. He had already had me pen these words months ahead of time...

I want to be that woman.

I long to be so trusting in God that he gets my immediate yes to whatever he asks of me, regardless of how I fear being viewed by the world and by those closest to my heart. Because all that matters is who HE says I am, and how much HE loves me, and nothing He could ever ask of me will alter that.

He knew in that moment that the words I would later write would require me to trust him with my heart. He knew that my saying yes would cost me something. He knew that he would be asking me to take my pride and hand it over to him. He knew that I would need him to reassure me that he loves me, and nothing will ever change that.

That's how much he loves us.

He runs ahead of us and writes our ending first, then waits for all our yeses to fill in the pages in between.

You Won!

Have you ever received anything in the mail notifying you that you've won some big prize for something you didn't even enter a contest for? It promises a large sum of cash or a shiny new car and seems too good to be true, until you read the fine print. While the prizes are spelled out in bold type covering nearly the entire page, the smaller print lists all the requirements that must be met before you can redeem your prize. You may have to order a subscription, sign up for a trial promotion, or sit through a time-share presentation that sucks ninety minutes from your life that you'll never get back. People usually throw these things in the trash because we've learned that if it sounds too good to be true, it probably is. There are sayings like, "There's no such thing as a free lunch" or "Nothing good ever comes for free."

My husband and I received such a prize once and had the same suspicious reaction. First an email popped up in my inbox saying I should be expecting a package from FedEx along with instructions that I would need to sign for the package and a link to track it. Well, I'm no dummy! I didn't order anything through FedEx and I wasn't about to click on some link that would infiltrate my computer with some nasty malware virus. No, sir! I deleted the nefarious email and continued with my day. When I returned home that evening my doorbell rang and there was FedEx with a flat package to deliver to me; they just needed my signature. I thought, *Wow, these hackers are getting more and more sophisticated.*

I signed for the package and carried it inside. Upon opening it the first words I read were, "Congratulations, you've won a trip to Hawaii!" I laughed at the absurdity of the letter and decided initially to throw it in the trash, but I thought I'd continue reading just to see what the latest scam was all about. The letter was from my credit card company and went on to explain that I had won a sweepstakes called "Priceless Surprises." My suspicious brain thought, *Yeah right, I never enter sweepstakes. There's always a catch.* The very next line that my eyes landed on said, "You don't have to enter this contest to win, and there's no catch!"

Huh?

Okay, well by "no catch" they must mean that the requirements are so minimal that it seems like you didn't have to do much to claim the prize.

Nope.

I read through the fine print and it said that all I had to do was prove my identity, in other words show them that I am who I say I am, and the prize package was mine. Indeed this was not a contest I had entered or a prize I had competed for. In fact, I had been entered without my knowledge. At the bottom of the letter was a phone number to call and speak with a representative. *All right, here is where the sales pitch will come in once they get me trapped on the phone.*

I called the number and heaved a big sigh, knowing I was about to be irritated and disappointed and I'd have to find a polite way to interrupt the rehearsed script to say that I wasn't interested in a monthly cheeses of the world shipment that I could cancel at any time.

A lovely woman answered the phone and after I identified myself and told her I had received a letter in the mail, she immediately said, "Oh, Jada, we've been expecting your call. You've won our grand prize. Isn't that exciting?"

"Um, I guess so…but I didn't actually *do* anything to earn a prize like this. How did this even happen?"

Friendly sweepstakes lady went on to tell me that the beauty in the contest is that you don't have to do anything to win it. That's why it's called "Priceless *Surprises.*" You are entered without even knowing, and the

winner receives a free gift, with no strings attached. She explained that I had been automatically entered to win when I had swiped my debit card. She told me what day and where the card was used. I remembered the day she was referencing.

The day that I had unknowingly entered the sweepstakes, I had used my debit card on a purchase at a nail salon. My daughter had been going through a rough season, and I'd taken her to the salon for a girl's day to lift her spirits. It was just a normal day spent with my girl. I didn't do anything to deserve a prize of this magnitude. And yet I'd been awarded the grand prize. Something that I could never have attained on my own.

The prize included an all-expense paid trip to a resort in Hawaii, complete with first-class airfare, activities like scuba diving, sunset cruises along the coast, and fancy dining experiences. This was something I never dreamed I would be able to do, and when I did dream of a trip to Hawaii (which I did often), my dreams were much smaller and less elaborate than this.

After some more convincing on sweepstakes lady's part, I went online and followed some of the links she gave me to research the contest and see for myself that it was, in fact, legitimate and other people had won a variety of fabulous prizes in the past. After I spent some time validating the contest and reading and rereading the documentation that had come in the mail, I started to get excited.

I determined I had gathered enough intel that it was time to call my husband and share the good news. He was working so I sent a quick text:

Call me when not busy, have something to tell you

He immediately replied:

Serving a search warrant, will be a bit. What's wrong?

Nothing wrong, just have big news hurry up

As the minutes ticked by I worked myself into an excited frenzy. What was taking him so long? Couldn't he fight crime a little faster? We won a freakin' trip to Hawaii! How can this even be possible?

Finally he called, and I gushed out the great news. "Babe, you're not gonna believe this. We won a trip to Hawaii!"

Crickets.

I asked him, "Did you hear me?"

He answered, "Yeah, very funny. What did you want to tell me?"

I insisted that we really did win a trip and I told him all about the email and the FedEx package and the letter and the nice sweepstakes lady I had talked to on the phone.

He sat there for half a beat and said, "Throw it in the trash. It's a scam."

He didn't believe it.

He is suspicious by nature. Innocent until proven guilty is a nice theory, but pretty much everyone he encounters is a suspect of "something" until they prove to him otherwise. He's cautious to a fault. So he told me to throw our "priceless" prize into the trash.

I didn't.

I had been convinced of its truth and its worth.

So I began convincing him of the same.

I explained all the details about how I had been entered and all the fabulous experiences that I and a guest of my choosing would embark upon.

He eventually acknowledged that it *could be* legit and immediately followed it up with, "Wait...you are taking ME as your guest, right?" Bless him.

Long story short, we believed this was a real free prize, we proved our identities, accepted the prize, and set off for sandy beaches and endless horizons in paradise. There were a few hiccups along the way, as first a volcano erupting postponed our journey to paradise, then a hurricane threatened to derail us from experiencing our prize. But eventually we landed in Hawaii. My sweet suspicious husband was skeptical of the validity of all of it up until the resort staff picked us up from the airport, holding a placard with our names emblazoned across the front as "winners." His wariness continued as we were ushered into a luxury SUV and offered cool eucalyptus-scented towels and refreshing, cold bottled Hawaiian water for the trip to the hotel. It was a LONG flight and I was ready to be pampered and have a refreshing drink. As I opened the bottle to take a drink, my husband looked at me aghast and aggressively

whispered, "What are you doing? Don't drink that! They're probably drugging us to knock us out and steal our organs!"

Seriously.

We didn't die. Obviously.

We enjoyed luxury and pampering that we never expected; we saw beauty that we never knew existed. And we did nothing to earn it.

Does the theme of getting a gift you didn't deserve resonate with you? It does with me. God sent his Son to pay a price that I would never fully grasp in exchange for my salvation and my forgiveness. I didn't ask for it. I didn't do anything to deserve it. I wasn't even born yet when it took place. Yet God knew about me. He knew he would create me and put a plan in motion for my very existence. And he knew that I would need his Son because I would be born into a fallen world.

When we won our dream vacation there were no strings attached. I simply had to believe it (and not throw it in the trash even though it seemed too good to be true), and I had to prove my identity to redeem my prize.

Merriam-Webster defines *redeem* as: to buy back, or to exchange for something of value.

Our salvation in Christ is the very same. You have already won the grand prize (without entering), which is eternal life and relationship with the one who created you. The exchange to "buy you back" from death was already completed when Christ died on the cross. The only thing left for you to do is redeem your prize of eternal life... And Christ already redeemed you. Believe the prize is real and that it is meant for you, even if you don't deserve it and did nothing to earn it. An exchange of something valuable already took place for you.

Galatians 3:13–14 (*THE MESSAGE*) tell us that we are redeemed:

> Christ **redeemed** us from that self-defeating, cursed life by absorbing it completely into himself. Do you remember the Scripture that says, "Cursed is everyone who hangs on a tree"? That is what happened when Jesus was nailed to the cross: He became a curse, and

*at the same time dissolved the curse. And now, because of that, the air is cleared, and we can see that Abraham's blessing is present and available for non-Jews, too. We are **all** able to receive God's life, his Spirit, in and with us **by believing**—just the way Abraham received it.*

In the same way that you claim your free gift of salvation, God has already claimed YOU, and you are HIS gift.

*In Him also we have received an inheritance [a destiny – **we were claimed by God** as His own], having been predestined (chosen, appointed beforehand) according to the purpose of Him who works everything in agreement with the counsel and design of His will* (Ephesians 1:11, AMP).

*Moreover because of what Christ has done, we have become **gifts to God that he Delights in**, for as part of God's sovereign plan we were chosen from the beginning to be his, and all things happen just as he decided long ago* (Ephesians 1:11, TLB).

All that's left to do is to know who you are. Your identity is the key to claiming your prize.

You are who GOD says you are.

NOT who others have told you that you are.

NOT who you've tried to mold yourself into becoming so you'll fit into the group that sits at the cool kids' lunch table.

But don't take my word for it. I'm just the sweepstakes lady. Do the research yourself.

You are set apart (Romans 8:30, GNTA; Psalm 4:3, NIV).

You are a child of God (John 1:12, NIV; 1 John 3:1, NCV).

You are a child of the one true King (Galatians 3:26, NIV; Romans 8:14, 16, NIV).

You are a beloved daughter of the King of Kings (2 Corinthians 6:18, AMP).

You are adored and deeply loved by the Maker of the Universe (Jeremiah 31:3, *THE MESSAGE*).

You are chosen (1 Peter 2:9–10, *THE MESSAGE*).

You are Known (Psalm 139:16–17, GNT).

You are worthy (Matthew 10:29–31, TLB).

You are loved (1 John 4:16, TLB).

ME: I can't even explain how it makes me feel that you "claimed" me and wanted me before I even existed.

GOD: You were always mine.

ME: Our trip to Hawaii was so extravagant. It was more than I could have ever hoped for.

GOD: I have so much more planned for you. My dreams for you are far bigger than you can imagine.

ME: I'm seriously nobody special. I don't deserve any of this.

GOD: Yes, you are. You are my daughter. I love you and I want to lavish you with so many things.

ME: That's nuts, I'm blessed beyond anything I could ever want!

GOD: You have no idea what's waiting for you at home with me.

Know who you are in Christ, believe that the prize is for you, and you can claim your free gift of eternal life with the one who made you and madly loves you. No strings attached.

*The payoff for a life of sin is death, but God is offering us a **free gift** – eternal life through our Lord Jesus, the Anointed One, the Liberating King* (Romans 6:23, *THE VOICE*).

Adequate

Shortly after our luxurious trip to Hawaii with its perfect sunny weather, eucalyptus-scented cool towelettes, fruity umbrella drinks, and towels in the shape of swans, my husband and I came down with the travel bug. We obviously couldn't afford to return to the island, so we did the next best thing. We decided to take a trip to Nashville. Now when we flew to Hawaii, we were provided with everything we needed. All our travel arrangements were made for us and we were provided with a detailed itinerary stating when we were scheduled to scuba dive, to float on the sunset cruise, visit the spa, and report to whatever fancy restaurant was on the agenda.

Having all that vacation planning done for me made me lazy. And I thought we would try something different. Instead of being in control of every detail of this trip like I normally would have been, I decided we would just load up the car and go. We would leave at whatever time we felt like it, stop to sightsee whenever we felt like it, and then pull over at the first hotel that struck our fancy as we rolled into Nashville.

Although I like the "idea" of being spontaneous, it's just not in my DNA. I'm the type of girl who needs to research and map out the most effective way to be reckless. I'm serious. I literally *plan* to be spontaneous. On any other trip I would have researched our destination, plotted out all our activities, and scheduled everything precisely. I would have bought tickets in advance and carried along my vacation binder. Yes, a vacation binder is a thing, with color-coded tabs of scheduled fun.

But not this time. This time I was sun-kissed, beach-relaxed, and surfer-chill. I was a new Jada. I was Maui Jada. Kind of like Maui Barbie, but fluffier, nerdier, and with a less defined foot arch. I decided we were just gonna load up the car, take off for the country music capital of the world, and wing this thing.

What could go wrong?

Well, first up would be that we drove until I felt like we needed gas or a break. Not that I paid any attention to where exactly we were at this time, because Maui Jada was chill. Which meant that I pulled our car off the interstate somewhere in a decidedly unsavory part of East St. Louis. I pulled into the first gas station I saw, which of course had bars on all the windows. My husband got out to pump the gas and promptly pointed out the drug paraphernalia on the ground at my feet.

Because why not?

He then left me standing there with drugs underfoot as he went out to the street to help push a car that had run out of gas, at which time I must move our car out of the way because this one was rapidly rolling toward us.

Off to a good start.

We drove for a few more hours until dinnertime, at which time we argued about where and what to eat and then drove past approximately 432 places because we couldn't make decisions about which place to stop at while driving 70 mph past said place. Why? Because plans are for sissies.

Still hopeful this whole thing was going to turn around.

We cruised into town late at night. The first thing I noticed were the no-vacancy signs. That seemed odd, but I thought to myself, *Maybe we just need to go a little farther off the interstate. There are like a thousand hotels here.* I started calling hotels near us and learned that they were all full and that if a room did become available, it would cost us approximately $618 per night, plus a firstborn male heir, eye of newt, and a drop of dragon's blood.

What is going on?

The Country Music Awards. That's what was going on. And had Maui

Jada been more Prepare-For-The-Worst-Hope-For-The-Best-Jada, then she might have known that the biggest event of the year, according to country music enthusiasts, was happening right smack dab in the middle of our spontaneous vacation.

So the current situation was this: we were hungry, tired, irritable, and it was approximately thirty degrees and freezing rain. Sleeping in the car was not an option for the following reasons:

1. Because we might have frozen to death.
2. Because we might have killed one another or turned to cannibalism to survive because snacks were running dangerously low.

We finally found a hotel with a room vacancy. Don't breathe a sigh of relief just yet. This was a room whose nightly rate was barely in the double digits. Which in hindsight seems overpriced. This was the kind of room where you sleep on top of the comforter with all your clothes on. Which we did.

As we entered our suite of salvation, we discovered what looked to be blood on the doorjamb, and possibly a bullet hole. And the toilet wasn't even bolted to the floor. All of this was discovered *after* we walked through what seemed like a literal cloud of marijuana smoke as we entered the room. The smell was overpowering and I'm certain we had a contact high, although I could have just been genuinely hungry and naturally chatty. Who knows?

We tried to get some sleep, determined that we would find better accommodations in the morning. Upon waking I discovered that my husband left his suitcase zipped up tight to avoid his clothes making him smell like a pothead. Do you think he shared this helpful tidbit with me? Nope. My suitcase was left wide open after I pulled out my toothbrush and hovered over the sink the night before, being careful not to put my toothbrush down on any surfaces that might contaminate it with who knows what kind of germs. We packed up to leave with my husband

smelling like a normal person and me having a rather "distinct" odor. As we get out into the sunshine, I looked at my husband's arm that he was scratching at and asked him, "Is that a bug bite of some sort on your arm?" He looked back at me and saw red angry bites on my neck and said, "Looks like whatever bit me got you, too."

Did I mention we were meeting my son's girlfriend's parents for the first time on this trip?

Oh yes, and I showed up to meet these lovely people smelling like I had just left a Willie Nelson festival in Colorado where I was exposed to some type of skin contagion.

The humiliation.

I can't even.

After we had aired out and applied some hydrocortisone, we decided to engage in a typical vacation-trap activity and take a tour of famous landmarks and homes of country music stars. We boarded the tour bus and set off. Our tour bus driver was a friendly conversational guy who strapped on his microphone headset and entertained us with stories of local legends and famous people he'd encountered throughout his career. We drove past several beautiful homes currently or previously owned by country music artists (at least we believed that's what we were seeing).

Our bus pulled to the side of the road in front of one home that had us all pulling out our cell phones to take photos and press our noses to the glass to get a better look. It was spectacular. Beautifully landscaped and constructed and large enough to comfortably fit ten of our families inside. As we *oohed* and *ahhhd*, feeling starstruck and more than a little envious of this beautiful home, our tour guide dropped a bombshell on us, saying, "That there is the gay-raj."

Say what? THAT IS A GARAGE?

He pulled our bus a little farther up the road and around the corner to the "real house." This was something to behold. It was single-handedly the most fancy and elaborate mansion I had ever personally laid eyes on. I was completely dumbstruck. Our driver leaned back and gave us a moment to take it all in, and to mentally consider how our houses back

home were shacks. Then he said something that had my husband and I cracking up and has stayed with us to this day.

He glanced over at the mansion and deadpan, without cracking a smile, said, "It's adequate. Just all ya need."

Adequate?

All you need?

Is he serious? THAT's how he's describing this mansion with the fifty-car garage, the hundreds of acres of land, the PERSONAL LAKE, and PRIVATE RUNWAY!?

Of course he was being facetious. And we laughed until tears rolled down our faces. And we have used those phrases ever since. "I love you" has been replaced with, "You're okay," "You're adequate," "You're all right, just all ya need."

Even though that trip started out a little rocky, and not being in control left me way out of my comfort zone, we ended up having a good time together and had an experience that left us with an inside joke to share together for the rest of our lives.

That trip changed my perspective on the word adequate. Some synonyms for adequate are satisfactory, acceptable, sufficient, suitable, and enough. I have lived my life struggling and striving to be a mansion; I would have even settled for being a fancy gay-raj. I have consistently put pressure on myself to be perfect and to be perceived as someone amazing and outstanding at whatever task I'm doing. It didn't matter if it was being a mom, a 911 dispatcher, a friend, a scrapbooker, a Christian, or a jewelry maker. I felt a desire to be the very best at it. But in order to be the best at something you have to know what the best looks like. You must be able to see clearly where the bar is set. Which means you need to observe others who are currently doing or have done whatever it is you're trying to master. Which led me inevitably to comparisons, and if I perceived someone was doing an amazing job at something, I immediately felt condemned that I would never measure up. If I wasn't immediately good at some activity, I abandoned it. But the thing is the Lord never asked me to be anything spectacular or fancy beyond what he created me

to be. He made me adequate. He made me enough. And he made you the exact same way. You have "just all ya need" inside of you to be awesome at whatever he has asked you to do. And only you can do it exactly as he wants it to be done. There is no need to try to control everything to be more than what is expected of you. Stop putting that kind of pressure on yourself. You are adequate. You are enough. And God is enough for YOU. He is all you need.

ME: I like to be in control. I like to have what I need. I like to be the expert. I like knowing what to expect. But with you I don't always have all that.

GOD: If you did, you wouldn't rely on me.

ME: I would just coast along comfortably instead.

GOD: I did not create you to coast.

ME: No matter how much I crave my comfort, my control, my normal, and my predictable, being with you and doing life your way means always being on a bit of shaky ground. Always craving something…more.

GOD: You can trust me. What do you want?

ME: I want to see things the way you see them. I'm tired of only thinking rationally. I want to glimpse Heaven. I want to believe things that are unbelievable. I want to trust what you have for me. I want to hear you and I want to tangibly feel you. I want to be overwhelmed by you. I want to be filled with Holy Spirit fire…hot to the touch. I want to be absorbed into you. I want to know about the beauty of Heaven waiting for me. I want you. Above all I want your abundant love.

GOD: You have it.

ME: I don't feel like I can just accept that.

GOD: You have had my abundant love all along and it never runs out. It will completely satisfy you. But you keep tucking crumbs from others into your pocket to save for later. Nothing and no one else will ever fully satisfy you.

ME: I am afraid sometimes that if I don't meet your expectations, that your love *will* run out.

GOD: You could disregard your assignment and do absolutely nothing for the rest of your life and I would love you the same…endlessly.

ME: Sometimes I don't even think I'm capable of telling other women about you. How can I adequately express with my words how much you love them? I don't have a college degree in English or literature. I'm not a theologian or any kind of expert at all. Why would they listen to what I have to say?

GOD: It's not about you. It's about me. And what I can do. I am enough, for you and for them.

ME: But there's more to it than just my willingness. I need to have something to say and be able to write it in a way that connects with women. I need inspiration to share what's in my heart. I need the time and the quiet space to do this thing you've asked me to do. You know I have a job, right!? And a mortgage! I can't just do this *one* thing! And don't get me started about how loud my house is—eight people live here! There is SO much stomping, yelling, door slamming, and *YouTube* going on that I can't even think straight. It's just not that easy to do this. <*pouts*>

GOD: I didn't say it would be.

ME: But… <*whines*>

GOD: I have more than enough of everything you need to do what I am calling you to do.

ME: My head knows that I should trust you, but how do I get my heart to catch up?

GOD: Have I ever let you down, or left you on your own with nothing?

ME: No. <*still sulking*>

GOD: Remember when money was tight, and you played the grocery shopping game with the kids?

ME: <*smiles at the memory*> Yes. We had twenty-five dollars in the budget to do the weekly shopping. We worked as a team and we got creative with foods that would stretch the farthest.

GOD: You taught them about money and coupons.

ME: And how to compare prices and net weight in ounces to get the best deal. We had fun together.

GOD: And you tithed.

ME: With the last dollars we had.

GOD: And did you go without?

ME: *<feels lump form in throat>* No, we always had enough.

GOD: What happened?

ME: Every week, my mom or someone else would turn up with extras they found BOGO, or food from their gardens. A little extra cash would turn up.

GOD: And the kids were okay?

ME: We were closer than ever.

GOD: I took care of you.

ME: Yes, you did. Our situation never felt desperate, although logically it *should* have.

GOD: Remember when I promised you that I would restore your family and that they would know me through you?

ME: *<eyes sting with unshed tears>* Yes. I wrote that promise down and read it over and over…hoping it was true.

GOD: Did I let you down? Or leave you all alone?

ME: No. Just the opposite. You gave me twice the family as before, and more love that I could have imagined.

GOD: You have my abundance. It's been inside of you all along. This is how I designed you. You are equipped with all you need to do what I've called you to do.

ME: Are you sure?

GOD: You're adequate. All I need.

Target Bags

I am obsessed with bags. I have an entire shelf in my closet filled with all sorts of bags. I have purses, wallets, wristlets, clutches, big bags, small bags, bags with interchangeable shells, bags for the beach, bags for hiking (which I literally never do...but there are SO many pockets!), bags for going out, bags to hold my computer, bags for hauling groceries. It doesn't matter what the occasion, I probably have a bag for it. When I go into a store I am immediately drawn to the bags; it could be a rack of drawstring athletic bags, or an elegant display of Coach purses, it doesn't matter, I just love bags.

I have deduced that my love for bags comes from a deep place within my psyche. I have never studied psychology, but I do strive to be self-actualizing and I can make a generalized diagnosis for my "bagaholic" behavior. I like to compartmentalize. I am constantly putting things into their assigned mental box, tote, tub, purse, wallet, pouch, zipper, snap, or magnetic pocket. This has been my coping mechanism all my life. If something was upsetting to me, I'd stick it in the *Do Not Open* box. If a beautiful moment occurred that I never wanted to forget, I'd slide that one gently into the *Precious Memories* pocket. This was a very useful tool throughout my life, particularly when working in 911 where I could compartmentalize all the negative things that I heard all day and file them away, then lock that up so I wouldn't carry all that ugly stuff home with me to my family.

As useful as this technique can be at times, it can also be harmful. It is very easy to compartmentalize our sin life and our Christian life separately, so they never overlap. Ultimately it's all one big glorious life that we're living, but it makes us feel better to keep the churchy parts away from the not so churchy parts.

The enemy will use this separation against us. He will try to keep us internally divided and hiding parts of ourselves. But your Heavenly Father knows every part of you. He knows what you have inside each one of your bags. The church bag. The sin bag. The work bag. The boyfriend bag. The best friend bag. The mistakes bag. The pride bag. The secret bag. And even the supersecret bag.

If we can tell by looking at our own baggage what's inside of it, don't you think the enemy can, too? His goal is to seek, kill, and destroy. How destroying to you would it be if your sin bag was dumped out on the floor in church, where you were supposed to be carrying your church bag? Devastating humiliation, right? The enemy rubs his hands together and squeals with glee at your humiliation and shame being on display for all to see. He wants nothing more than to slap heavy chains of condemnation around your wrists, so you stay weighted down under your own grief and shame. Because with all your shame dumped out and the chains binding you, you are no longer a threat to him. You are no longer working for the Kingdom of God. You are no longer fulfilling your purposes. You are right where the enemy wants you. Maybe you're in that place right now, where you can nearly feel the metal against your skin and the heaviness of the steel wrapped around your flesh. It may feel at this very moment like you are unusable by God.

But that is simply a lie that the enemy is begging you to believe.

The truth is that you can drop those chains.

You can drop them because you never stopped being useable by God.

It is possible for the heaviness of those chains to lighten. God already knew what was in the bag before you ever filled it up. All the enemy did was show you that he knows what's in the bag, too.

So what?

What the enemy thinks about the mistakes you've made or the guilt and shame you carry doesn't matter. IT DOESN'T MATTER! Only what God thinks about it matters. And here's the harder pill to swallow: all those people around you whom you're so concerned about what *they* will think of you…they don't matter, either. NONE OF THEM MATTER. If you have brought your shame before God, laid down at his feet everything you've done that is making you feel this way, and you have asked him for forgiveness…then it's done. NOT ONE PERSON'S opinion on it matters. Only God's. And he threw away your bag of shame and regret and handed you forgiveness. You jumped back into the dumpster to retrieve your old bag. Maybe because it's comfortable for you to have it with you. Maybe because the enemy whispered to you that you need it and you can't go on without it, or you deserve to carry it around. I don't know. Whatever the reason, the enemy will keep trying to use the garbage against you.

I own this one specific bag that I used to carry around with me when I was in an especially compartmentalizing and sinful time in my life. This was a time when I was going to church regularly, in the Word every day, and attending Bible studies. I was doing everything I was supposed to be doing. But at *other* times, outside of my churchy circles, I was engaging in behavior that I knew was wrong. But I kept it all separate. The bag I was carrying with me was a tote bag I had bought at Target. It wasn't anything special, just a black canvas bag with little geometric bunnies all over it. It was small and cute, and I could toss extra stuff I needed to carry around with me into the bag and not weigh down my purse. The bag didn't have one sole purpose; I used it for lots of things. I took it to work or to the park and on trips, or outings with friends. However, I also took this bag along when my plans weren't so innocent. When I was headed out partying and I wasn't sure if I'd be coming home or not, I would throw extra clothes, toothbrush, and the like into the bag so I could go straight from the party, or from whoever's house I had passed out at, to work the next day. That cute bag was witness to some very uncute moments in my life.

Fast-forward several years. My life looked completely different. The bag sat stored in a box on a shelf somewhere in my closet. I was no longer

trying to fill some empty place inside with alcohol or men or anything else. My relationship with God was stronger than ever and he was all I needed. I was in the best place I'd ever been in my life. I was sitting in church, listening to the message, singing the worship songs, praising my Heavenly Father. The Holy Spirit was there, palpable and very real and present in the room. I felt the presence of the Lord come over me and tell me that I had a purpose, and I was supposed to step out in faith and trust him and do exactly what he'd asked me to do. He loved me and he was proud of me and I possessed something special and unique that only I could give to others in his name.

WOW, right? I felt overwhelmed. My whole body was buzzing with the touch of God. My eyes were closed with tears brimming under my lashes, just beginning to fill enough to roll down my cheeks. My face was tilted upward, basking in my Father's love; my hands were wide open in worship, surrendering and accepting whatever the Lord had to give me. I was filled with passion and on fire for God. It was truly an amazing moment.

Then I opened my eyes.

Even in that beautiful moment, the enemy had been lurking and watching…and waiting.

My eyes opened, and the blurriness started to clear as the tears finally escaped down my face. And my eyes landed on a woman diagonal from me, just a few feet away, and at her feet was a black duffel bag with little geometric bunnies all over it.

And the condemnation fell on me like a heavy, wet, weighted blanket.

And the enemy's whispers in my ear began immediately.

Who do you think you are?

You're trashy.

You have nothing to give to anyone.

If any of these women knew who you "really" are, they wouldn't even let you in the door.

Have you forgotten who you are?

You're just pretending to be some "Christian girl" in here…what a joke!

I know all about who you really are and everything you've done.

You can't just walk away from who you are and where you've been.

You don't have a purpose...and if you did you already messed that up long ago.

It's too late for you.

All you can do now is sit down and shut up and hope no one figures out you're an impostor.

I could hear the blood pumping in my ears, like crashing waves. Like I had a big seashell held close to each of my ears, blocking out everything else. I couldn't hear Pastor Tim's words any longer; he sounded like a far-off background white noise. I couldn't hear Lindsey, Tara, or Chanelle on the worship team. Their voices crying out to God in song and praise had just moments before pierced my heart as they so often had in the past. Their voices had time and again been the conduit for God to pursue me, reach me, catch me, and hold me. But now...they were so far away I couldn't hear them anymore. All I could hear was the whispering, so deafening, seeming to come at me from all sides. I felt like I'd been plucked out of a dream state and slammed into a cold, harsh reality. Who DID I think I was? I was nobody. I had to hide who I truly was, so no one would discover all the ugly parts that made up the girl they saw sitting in church every Sunday. I felt heavy and defeated and sad.

Then something changed.

A tiny glimmer of light got through, and I heard something different.

No.

That is not true.

Praise.

That was it. No. That is not true. Praise. Three simple sentences that fell over me so softly, and yet they were mighty and powerful. The enemy was battling strongly against me, but my GOD IS STRONGER. The enemy was expending a tremendous amount of energy to suffocate me, but all God had to do was breathe gently three simple things in my direction to break through the enemy's lies and come after me. My Father loves me so much that he was not willing to let me go.

He came after me.

And around all the mental anguish and loud rushing sounds of shame I heard my Heavenly Father softly but clearly and commandingly. *No. That is not true. Praise.*

So in my humility, I glanced upward ever so slightly. I opened my lips a fraction of an inch and muttered under my breath the words to the song being sang. I slowly began to hear the worship team again. Then I raised my voice a bit louder. The music soared around me. I tilted my head further up in defiance of the lies the enemy had whispered over me. The crashing whisper in my ears seemed to evaporate like mist. I lifted my hands high in the air, feeling with every beat of the music my love for God pulsing from my hands toward my King and coming crashing back into me, nearly knocking me off my feet. I sang my praises to the Lord until my throat was raw. I threw my energy and love toward the one who made me with as much force as I could manifest.

And the enemy was defeated.

I don't know how the enemy left or when he left. And I don't care. He just wasn't there anymore.

All I had to do was praise.

God knew he had reached me. He knew that he was setting me on a path that day that would change the course of my life forever. A path that would potentially reach so many of God's daughters and set them free. The enemy knew it, too. And that made me dangerous. He needed to stop me and to shut me up before I ever even opened my mouth.

And he tried to use a Target bag to do it. He used something so simple to visually trigger me and try to put me in my place...a place in which he wanted me to stay. The enemy sees the logos on the baggage we carry, and he knows where to aim his arrows. If it happens to be an actual target on the bag he's aiming at, that makes it all that much easier for him. But it doesn't matter what name or logo is on our baggage. God has renamed all of it. CHOSEN. FORGIVEN. MINE. The enemy's arrows cannot penetrate the names of God's daughters, so long as we remember who we are and whose we are.

That Target bag holds no magic power. It's just a cute tote bag. I still have it, and when I look at it I don't feel any waves of condemnation. God already broke the enemy's power there. I look at it now and I'm reminded that God fought for me. He reached into the dark place of my mind and he snatched me back from the enemy's grip, and told the enemy, "No, you will not have her. She belongs to me."

And it also reminds me that I'm long overdue for a Target shopping spree.

ME: I can't believe I could get so completely thrown off guard by the enemy's schemes with something so simple.

GOD: Don't underestimate him. You always need to be on guard.

ME: That is slightly terrifying. What if he comes after me again?

GOD: He will.

ME: Well, that's certainly comforting.

GOD: As long as you continue to do the things I ask of you, he will hate you.

ME: You are really selling me on this obeying you thing. *<rolls eyes>*

GOD: Stay close to me. You'll be fine.

ME: But it seems counterintuitive. The closer I am to you…the harder he comes after me.

GOD: You are dangerous.

ME: That seems dramatic.

GOD: You can't see the big picture yet. But HE KNOWS what I am capable of. HE KNOWS how far and wide I can use my daughters with the purposes I set before them.

ME: Wow…

GOD: He seeks to destroy you and all that I have planned for you.

ME: But you won't let that happen, right?

GOD: Stay close to me. I will not let him have any one of you.

ME: You fought for me back then.

GOD: I will always come for you.

ME: No matter what? No matter how many times I need to be rescued?

GOD: I will never leave you.
ME: You promise?
GOD: I promise.

If you have given your life to the Lord, you are free. But free doesn't mean *trouble-free*. Things are still going to happen in life that knock you off balance. The enemy will continually try to sneak in and lie to you about who you are. You must stay on guard. Stay close to the Father. Remind yourself daily that you belong to the Lord. You are a daughter of the King. You are royalty. You are not the shameful thing from your past. You are not your failure or your addiction. When the enemy shows up whispering in your ear, praise. Even if you don't feel like it. Even if all you can muster up is a mumbled word or two. Talk above the whispering. Push through the lies you're hearing and praise your Heavenly Father. Sing your favorite worship song, or whisper thanks to him for waking you up that day. It doesn't matter. Just praise him. And the enemy's lies will quiet and disappear. And when you find yourself on the other side of the darkness, look around. If you see one of your sisters suffering under the weight of the enemy's attack…grab her hands and praise with her.

Then take yourselves to Target and buy a cute bag.

GUEST SPEAKER

ME: Lord! Is this some kind of JOKE? What in the legit crap is actually happening here? I am more than a little irritated with you right now! I feel like you tricked me and set me up to fail! How could you do this?

> **GOD:** Would you have agreed to it, had you known all the details?
> **ME:** NO. I absolutely would NOT have.
> **GOD:** You're right where I want you.
> **ME:** But this is insane! It is so awkward and uncomfortable. I don't want to do this!
> **GOD:** I am asking you to do this.
> **ME:** I don't GET IT! Why?
> **GOD:** That doesn't matter right now. Do you trust me?
> **ME:** <folds arms, breathes deeply through clenched teeth> Yesssss.
> **GOD:** Do this.
> **ME:** Fine.

At the time this conversation with God took place, I was dealing with a lot of flooding in our community through my work. The entire state of Missouri was experiencing record-setting river levels and flooding. There were residents and business owners in my hometown who were affected and struggling. Some service organizations had stepped up to collect

donations and try to help these families. Congregations from around our entire state were stepping up to offer their assistance as well.

I was contacted by one of these congregations in a neighboring county and asked to come and talk to them about the current flooding situations and how they could provide some help to those in need. Although public speaking is not my favorite thing to do, I thought to myself, *Okay, sure, no big deal.* I had previously talked a bit about flood relief in front of my own congregation when my pastor called me up to do so. This would be no different; just a few minutes of anxiety and then I'd be done, and it would possibly help bring some relief to the people in my community who were in need. Seemed like a fair trade off.

They had two scheduled services the following Sunday morning. I showed up a little early to find my contact person and scope out the place. It was a lovely church, with an organ and hymnals in the pew backs, along with red-letter KJVs interspersed throughout. I circumvented the group of congregants gathered near the front door, politely saying hello then asking where I might find "Cheryl," who would direct me where to go.

This was my first mistake.

Had I walked through this welcoming crowd, I surely would have been handed one of the Sunday church bulletins outlining the day's service. As it turned out, I went in blind instead. As I made my way to the front of the church a very nice man introduced himself as Roger, who I presumed was the pastor. He made sure he had the pronunciation of my name correct. Which was fair since it's a unique name and it is apparently very difficult for people to pronounce. I've been called Jah-dah, Jade, Data, Dana, Jadda-the-hut. Seriously. Kids are cruel. It's come down to me introducing myself as "Jada, like Jada Pinkett-Smith." Then as if by magic, it all makes sense, and they can say "Jada" with ease.

I settled into a pew second from the front as the rest of the people began to file in and fill up the back rows. I will never understand why people do this. Why would you sit in the back row of church? You're clearly closer to God in the front. Duh. Anyway, I digress.

"Pastor" Roger led them all in a brief prayer, sang a hymn, and then

introduced me to come and talk about the river flooding and how we could help those in need. This seemed like a nice spot for me to slip in, right after the church announcements about vacation Bible school and upcoming potlucks. I would give my five-minute update on current conditions and how the church can be the hand of God, then they could get into the meat and potatoes of their sermon and worship. Easy-peasy.

I popped up to the front of the church and I gave them information on donation locations and the types of families I had encountered in my job and the specific needs that they had. Then I thanked them for inviting me to come speak and turned the mic back over to a slightly confused-looking Roger. He graciously thanked me for coming as well and prayed again with the church, then wished them all a safe and blessed week and dismissed them.

Wait...what? Where is the meat and potatoes?

I mean everyone is eager to get to lunch after church, but this seemed abrupt. The next service didn't start for over an hour. I sat there confused. As the church service cleared out, I saw a discarded bulletin sitting in the pew behind me. I grabbed it and began reading it. I had plenty of time because I had an entire hour to kill before the next service began. Emblazoned across the front in bold fancy font were the words GUEST SPEAKER JADA MCCLINTICK.

What the ever loving...?

Their pastor, who was not Roger, and was in fact a woman named Amanda, was out of town at a conference and I was slotted to be their meat and potatoes.

Panic set in.

What in the world had I gotten myself into? More accurately, what in the name of all things Holy had God gotten me into? This could not be happening. I was not qualified for any of this.

As the second service time loomed ahead of me, a young woman who was assigned to read the group prayer and make introductions this time around approached me to introduce herself and thank me for being there. She was a pretty young mother, pulling two very well-behaved and

beautiful toddlers along with her, and had another child on the way that looked like he or she might decide to make their appearance and be born at any moment. At the time, I felt like I'd watched enough *Grey's Anatomy* that I was far more qualified to deliver her baby than to speak in front of a church. She had been on stage, practicing the next service's worship songs. As she came down the steps and up to the pews, I took this opportunity to apologize all over myself for misunderstanding what they were asking me to do when they originally requested that I come and talk about flooding. I told her how abbreviated the first service had been and that I would do my best to talk longer at this service, but that my material was pretty dry and most definitely was *not* a sermon. She was very gracious and said they were just grateful that I was willing to come and share with them and fill in while their pastor and her husband were away at a conference.

Well, I was in this now, and it was not like we could cancel church— the show must go on. So I gritted my teeth and pushed through the next service, all the while feeling embarrassed, unqualified, and just plain stupid. All I could do was pray that these people already had Jesus in their hearts and brought him with them to church that day, because I certainly did not deliver Jesus to this flock while I talked about river levels, mud, and FEMA.

At the end of each service I had the pleasure of visiting with the people from that church; in fact, I had plenty of time, as I had only filled five of the expected thirty to forty-five minutes. This church was filled with such kind and gracious people. They embodied the essence of small-town hospitality. Many of the older congregation knew my husband and his family, having raised their own families in the same neighborhood. They were welcoming and warm and, by their kindness, eased the panic-stricken anxiety buzzing in my veins.

Sometimes God asks us to do things that seem outside of what we know our capabilities to be. And if you're anything like me, sometimes he will "place" you into a situation that he knows you would never enter willingly on your own. But he never does anything without a reason. Every detail he orchestrates is part of a greater plan that we cannot see

from ground level. What we see is merely a corner of the painting, or a few stitches of an enormous tapestry. Sometimes we receive revelation and we see a piece of an image take shape, but we are still blinded in our humanity from seeing the entire beautiful picture. God doesn't keep all the "why's" and the big picture from us to be cruel. We just aren't prepared or designed to take that much in. Our thinking is finite, where God's thoughts have no boundaries or limitations. The Word says that God's thoughts are higher than ours. We were not designed to think like God. That's simply not how it works. There are some things that we will not understand this side of heaven. But we can trust in the fact that there is purpose in all of it. Every single situation and awkward assignment.

> *"I don't think the way you think. The way you work isn't the way I work... For as the sky soars high above earth, so the way I work surpasses the way you work, and the way I think is beyond the way you think. Just as rain and snow descend from the skies and don't go back until they've watered the earth, doing their work of making things grow and blossom, producing seed for farmers and food for the hungry, so will the words that come out of my mouth not come back empty-handed. They'll do the work I sent them to do, they'll complete the assignment I gave them"* (Isaiah 55:8–11, *THE MESSAGE*).

Whatever God tells you to do, those words have a work to do. You are the means by which the work will get done. God will have his way, no matter what. We already know how the story ends, and God wins. If you won't do what he asks you to do, it won't stop the plan from unfolding. He won't force you; you have free will. He'll simply find someone else to do the work of his words. But wouldn't it be a shame if you got to heaven to find that he had so many parts he wanted you to play as his great purpose took shape? He won't love you any less, that's a fact, but you will have missed out on an opportunity to be a part of something bigger than yourself. Bigger than the world as we know it. The part he's asked you to play

may seem insignificant and may not even make any sense, but it doesn't have to. He wastes nothing.

I still don't entirely know why he put me in such an uncomfortable position that day and asked me to be their guest speaker. All I know is that I was scared and irritated with him for putting me there. But I did it anyway, because he asked me to. And there is never a good enough reason not to obey God. His words *will* complete the assignment he gave them; it all comes down to whether you are willing to be the one who does the work of his words.

ME: You have asked me to do some things over the years that are just plain nuts. I'm ashamed to say that I haven't always done them. Too often, I let fear get in the way of obedience. But when I do follow through with what you ask of me, two things are always true 100 percent of the time. First, they make me uncomfortable. And second, there is always something surprising that happens that ends up blessing me.

GOD: I will never ask you to do something that will harm you.

ME: I know that in my head, but that immediate flooding of panic and being afraid of looking stupid in front of other people is terrifying.

GOD: Are their thoughts higher than mine?

ME: Oh, nice. I see what you did there. No, of course not. I care that I'm pleasing you, not the world. So obviously I shouldn't care what other people think. But my pride still gets in the way.

GOD: Maybe that is why I ask you do to things. Things that will challenge your pride.

ME: I feel like there are easier ways to accomplish this. You're God, can't you just remove the prideful parts from my character?

GOD: You are not my puppet. You are my daughter.

ME: But you could *make* me into the perfect daughter who loves you and does everything you ask. I'm totally fine with that! The fleshly part of me has only gotten me into trouble!

GOD: How would you feel if your husband were *forced* to love you,

rather than *choosing* to? How would you feel if your best friends were *forced* to spend time with you?

ME: Oh. Well...I wouldn't feel very loved or special. I definitely wouldn't feel chosen. I would feel like they were only there because they had to be. And if they were no longer forced, they would abandon me.

GOD: When I watch you struggle to be more like my Son, when you are striving to overcome things like your pride, I see your love for me. I see that you trust me.

ME: I do love you and I do trust you. And I want more than anything to be like Jesus. But it's hard! I don't have all the information, and I don't understand how all the pieces fit together. Everything I've went through and all the hours I've spent riding the Hot Mess Express—how can all of *that* possibly work into your plan?

GOD: It does. Trust me.

ME: Do you promise that one day when I see you face-to-face that I will get all the answers I need to fill in the blanks?

GOD: I promise.

911

"I've been shot in the head...I'm a nurse...I'm about to lose consciousness... I only have a few minutes to tell you who did this..."

For eighteen years I worked as a 911 dispatcher and I was often asked, "What's the craziest call you've ever taken?" And this call is the one that always comes to mind. I had taken my fair share of calls of medical emergencies, but not often from the victim of a shooting themselves, and never from a victim who had just been shot in the head. This was a first. For one millisecond I was shocked as my brain tried to register what I had just heard. I couldn't have heard her calmly delivered words correctly, could I? But I had indeed heard them correctly, and my fingers and voice had already flown into action and began to document her rapid account of the events that had just unfolded and her description of her assailant, while simultaneously keying up the mic on the radio and sending responders to help her. I was naïve enough at that point in my career to think to myself, *She's a nurse. She isn't a bad person; she helps people for a living. How can something like this have happened to a person like her?*

Emergencies and tragedies don't discriminate. Everyone experiences them equally and I have taken many different types of 911 calls from many different types of people: young; old; rich; poor; every race, color, and creed; hysterical; calm; arrogant; kind; broken; bleeding; scared; and uncertain. And many of the calls were ugly. Hearing day after day,

minute after minute, about the atrocities that one human being can inflict upon another is enough to make you lose your compassion for the entire human race. It's enough to make your heart harden and to cause you to lose hope that there is any good left in people at all.

You see, people don't typically call 911 when they are having a *good* day. They are, in fact, often having the *worst* day of their lives. They are not usually patient, kind, or understanding. They aren't calling to say, "Hello, how are you today?" Instead they are angry, disappointed, heartbroken, desperate, scared, anxious, or flat-out terrified. Their bodies are reacting physically to their circumstances as well. Hearts racing, palms sweating, shallow breathing, inability to focus, headache, stomachache… the list goes on. They have an immediate need to stop feeling the way they are currently feeling. They need relief. They need help.

So they call 911.

They need to get the situation, whatever it is, fixed and under control RIGHT NOW, so they can get their bodies to regulate and their lives back into a comfortable and normal state of being. Callers often want to rush through the necessary questions, or skip them altogether, impatiently yelling, "*Just get them here NOW!*"

We do the very same thing with God.

We treat God like 911.

We wait until something feels catastrophic to us, then we cry out to God in our emergency and plead for help. And we want that help *right now*. We want whatever is weighing us down to be removed. We want our problem to disappear into thin air. We expect God to wave a magic wand and return things to the way they were supposed to be, according to the expectations *we* set for our lives. And just like the impatient 911 caller, we don't want to sit through God's conversations and questions. We just want him to answer when we call and fix the problem immediately.

But that's not always how God works. He wants a relationship with you. He wants to work through difficult times *with* you, to grow you and make you more and more each day into the person he created you to be. And that won't happen if he flips a switch and instantly fixes every trouble you

encounter the second you cry out. It's true that God is there all the time, but he is not a 911 operator and he doesn't work at the twenty-four-hour home-shopping network. You can't click on God whenever you get yourself in a bind and order up a miracle with two-day free shipping.

God is not *Amazon Prime*.

Eric Church sings a country song called "Some of It," which contains an amazing lyric that says this: "God ain't a wishin' well."

Wow.

Mind-blown.

How many times have we treated God just exactly like this, like a wishing well? A wishing well doesn't cost you much. You drop in a coin (usually a penny), close your eyes, and ask for what you want. Simple. Wishing wells were developed out of folklore, where it was believed that at certain wells *any spoken wish* would be granted.

Any spoken wish…

It would be very easy to slather some scripture over this like mayo on bread and justify our wishing-well mentality.

Matthew 7:7 (TLB) says: "Ask, and you will be given what you ask for. Seek, and you will find. Knock, and the door will be opened."

But God is not here to grant *any spoken wish*. That's not how it works. Nor is he a genie in in a bottle, waiting to grant us our three wishes. Does he hear all our wishes? Yes, of course. He created us with desires, and longing that only he can fulfill. This does not mean we get whatever we want. In fact, rarely do we get exactly what we want. God knows what we *need*, what will make us whole, and it doesn't usually resemble what we thought we wanted in the first place.

If you are praying to the Father and asking for anything in his name, he hears you. But he isn't going to fulfill your every whim.

Mainly because sometimes the stuff we ask for is just plain dumb.

Sometimes it doesn't make sense for the purpose he has for us, or it could even have the potential to harm us if we got our own way. But we can't see the big picture and we don't know any better. We want what we want, when we want it.

Just get them here now!
Fix my problems quick!
Make this hurt stop!

We are humans made of flesh and driven by our desires. But God doesn't respond to the request alone. God responds to the heart behind the asker. If what you are coming to him for is coming from a pure heart, from a place where you are seeking an encounter with your creator or to further the call he has placed on your life, you are far more likely to receive. However, if what you are asking for is not biblical, or only serves to improve your own personal situation with disregard for others, your "wish" is not likely to come true, particularly if doesn't cost you anything. You can't simply throw a penny at God and get whatever you want.

God ain't a wishin' well.

God can save us from anything. But he requires our faith to keep us moving forward toward all that he has for us. And faith is hard sometimes.

Peter knew firsthand how someone could be saved then begin to lose faith almost immediately and find themselves in need of a 911 prayer.

Peter, suddenly bold, said, "Master, if it's really you, call me to come to you on the water."

He said, "Come ahead."

Jumping out of the boat, Peter walked on the water to Jesus. But when he looked down at the waves churning beneath his feet, he lost his nerve and started to sink. He cried, "Master, save me!"

Jesus didn't hesitate. He reached down and grabbed his hand. Then he said, "Faint-heart, what got into you?"
Matthew 14:28–31 (*THE MESSAGE*)

Sometimes getting to the other side of your situation, whatever it is, will take some work.

Faith is work.

Trusting God takes practice.

Ultimately God is good. Always. He has a good purpose for you, but the process can sometimes be painful. It may cost you something. After all, he is trying to make you into something new, something different and changed. Something better. Simply waving a wand and improving your circumstances would leave you in the same place as a person. And God loves you too much to leave you as you are. If he did, you would simply find yourself in a similar situation later down the road, again crying out to God to fix it.

And sometimes we do just that.

We are resistant to answer the questions that need answering, and resistant to develop the things that need developed inside of us to make us better equipped to manage these circumstances. We find ourselves in the same boat on the same water, facing the same storms over and over, and we don't quite fully trust God after he calms the storm to step out and walk to him on the water. If we did, he would show us a different way. A way that would keep that storm from causing us panic ever again. Giving us our way every time we asked for it would be counterproductive and wouldn't make us into anything new that God could use. Things must be broken before something new can be made from them.

Think of it like this. Would you give your own children everything they ask for? No, of course not, because you'd have dragons, unicorns, and ponies in all your backyards. And the kids would be eating cake and candy for every meal and the next generation would all have rotten teeth. We can't have that. That doesn't make a healthy society for our future. Dragons and dentures everywhere would be chaos.

When my oldest son Tristen was about three and a half, I was pregnant with my second child and didn't yet know the gender of the baby. We asked my son whether he wanted a baby brother or a baby sister and did he know what he thought we should name the baby. Now you need to understand that my son was a crazy-smart toddler and very well spoken, like a tiny adult. By age two he could point to nearly any car in the Walmart parking lot and tell you the make and model. By three he could tell you which presidents were on which denominations of money and

what numerical order their presidency fell into. I'd love to be able to take credit for this, but I can't. None of this was my doing at all. He was just a bright kid with phenomenal preschool teachers.

So when we asked him whether he preferred a brother or sister and what he would name him or her, we knew the answer would be well thought out. He considered our question for a moment then declared that he didn't want either one. Not a brother or a sister. Well, since my belly was most definitely growing, this wasn't going to be a valid option. We pressed him further and said, "Well, what exactly do you want then, if you don't want a brother or a sister?" He smiled sweetly and answered with the confidence of a child who up to that point was an only child and had pretty much gotten whatever he asked for, "I want a baby hawk, and I want to name it George-Susie."

He got a brother.

No feathers, wings, or beak. And we didn't take him up on his name suggestions, either, to which my second son Jackson is ever so grateful.

We just couldn't fulfill his wish. It didn't make sense. Not that we didn't want to appease him and make him happy, but what he was asking was not feasible, and even using his choice of name would have certainly caused his brother an unfair amount of teasing and humiliation. Tristen didn't mean it that way; it simply would have been a bad end result that he was too little to understand at the time.

Sometimes we are just too immature in our faith to know that what we are asking God for is not what is best for us. Sometimes in our panic, we just want the quick fix, when God has so much more for us than a Band-Aid solution. He has heart transformation in mind.

ME: I'm sorry that for so many years of my life, I only acknowledged you when I needed something from you.

GOD: I hear the desperate cries, too.

ME: But there is so much more to a relationship with you. There is so much people are missing out on by ignoring you until they have an emergency.

GOD: I am grateful every time one of my children reaches out to me. But I do want more.

ME: Back when I first knew you, sometimes you would answer my 911 prayers.

GOD: I needed to build your trust in me.

ME: And later, sometimes my prayers went unanswered for years. Some I still don't have answers to.

GOD: Now you know me. You have learned to trust in my timing.

ME: I wish so badly that I would have had a relationship with you sooner. I would have done so many more things your way, rather than trying to do things on my own then freaking out and asking you to fix what I had messed up.

GOD: I used all of that. It has made you who you are today. You have compassion for others experiencing things you went through doing it *your way.*

ME: I know I won't always get it right, but I want you in it with me, every single day, not just the desperate ones.

GOD: That's all I want, too.

God wants a relationship with you. He doesn't want you to come to him only when you are falling apart and needing 911 or a wish granted. He wants you every day. In the good and the bad, in the thrilling and the boring. He wants all of it. He loves you so much and wants to hear from you every single day. Every detail. He wants to share in your frustrations and your triumphs. He wants to feel your hurt feelings alongside you, and he wants to experience joy with you, too.

God will always be there and will always hear you when you cry out to him. He will never ignore you. He will calm the raging storms in your life and call you out to walk upon the water in faith. But he also desires to call you out on calm seas as well. Don't wait for the next desperate time, to cry out for a desperate measure. Step out of the boat, today, while things are calm and peaceful. Spend time with him. Let him lead you beside still waters (Psalm 23:2). He has something amazing for you.

TRIBE

There is almost nothing in this world more important for a woman than to have a tribe. Women need other women. It's as simple as that. And I would even go as far as to say that your tribe needs to consist of *at least* three girls. You can add even more to your tribe, but don't expand it just for the sake of numbers. It's not about high membership. It's about being connected to women who feed your soul. Women to whom you can offer something of yourself to in the unique way that only you can, because that's how God made you.

Two women who are best friends is great, but sometimes two women can be so synced up (and not only in a monthly sort of way) that they can start to think and act too much alike. Sometimes we need that third person to be our moment of clarity and sanity. We need this third girl to tell us to put down the porcelain pineapple with *beach please* emblazoned across it at Target. We don't need the pineapple! And girl number one may be just as Target irresponsible as you and become a total enabler. This is where girl three comes in and asks you if you *really* need that pineapple, and where are you going to put it? At other times friend number one may be trying to convince the other two that a seven-mile workout, uphill *all* the ways, is a fantastic idea, while you and friend two inform her that you are positive that body parts will actually fall off on the walking trail if you attempt this. And nobody wants to clean that up.

You need at least three.

It's all about balance.

The Bible talks about a cord or a rope of three strands, referring to friendship and to the relationship between husband and wife with Christ. It's also been referred to as "God's Knot," which is both a great name for a band or a Christian street gang. Neither of which I am currently a part of. #goals.

"And if one person is vulnerable to attack, two can drive the attacker away. As the saying goes, A rope made of three strands is not quickly broken" (Ecclesiastes 4:12, *THE VOICE*).

In other words, you and one of your best girlfriends can put up quite a fight against the enemy. But add a third girl to the mix and you become a force to be reckoned with. Not today, Satan.

We need our girlfriends. We need to spend time with them and invest in our relationships with them. In fact, Jesus himself values the gathering of friends so much so that he said if you get together with your girlfriends and acknowledge him, he will hang out with you!

"And when two or three of you are together because of me, you can be sure that I'll be there" (Matthew 18–20, *THE MESSAGE*).

JESUS the SON of the ACTUAL LIVING GOD is going to hang out with you and your friends. Seriously? Yes! Seriously! It doesn't matter if you're shopping for shoes, having a latte, killing it at Zumba, or carb loading on rice balls at the Italian buffet. Whatever it is, if you're Jesus loving and acknowledge him as part of your group and part of your lives, he's there.

I have a couple of best friends named Connie and Kendra. My daughter has nicknamed us "The Grapes." I'm not sure if it's because she thinks we are plump and round, or because we have matching purple workout gear. We attempted to change our name once to mirror a box of crackers. Our new name was to be the "Salty Squares," after seeing the snack on a

shelf at Trader Joe's. It's fitting because we are most definitely salty, sassy, and sarcastic, and our idea of a good time is a visit to the half-price bookstore and our favorite restaurant. We aren't exactly hitting the nightclubs over here. We have the perfect mix of chemistry, and more importantly we just "get" one another and accept one another for exactly who we are. There is no need to pretend to be something we aren't around each other. This is what makes a great tribe.

You need girlfriends in your life who tell you, "You got this!" You need them to be your own personal varsity cheerleading squad and remind you that you are amazing. I don't mean they blow smoke and inflate your ego. I mean you hang around girls who aren't jealous of you and aren't trying to squash your potential so they feel better about themselves. Instead you hang around girls who really see and appreciate all the great parts about you and remind you of them when you forget and get down on yourself. My friend Kendra does this perfectly. She is wicked smart, sarcastic, funny, loyal, and she gave "pretty" its name and hung a Coach purse on its arm. You cannot be around this girl longer than three seconds and not have mad respect for her. She is the fierce lioness of our group, always protective and aware of everything around us. She has stopped us from chatting and blindly walking into traffic too many times to count. She is the girl who will show up for a walk with extra water, some ibuprofen, a sewing kit, a rape whistle, and a hacksaw. Because you just never know. In friendships and in life, she is the A-team. So when she tells me to hold up and cut myself some slack and then reminds me that I am more than capable of conquering whatever giant is looming in front of me and reminds me of all the ways I'm slaying this thing called life, I listen to her. Get yourself a Kendra.

You need girls around you, woven into the very fabric of your life, who really *get* you, who accept you, who push you, who stretch you, and who find joy in you. Connie is the girl who does every single one of these things. We like the same things, we find the same things funny, and we have many of the same habits. I can be totally myself around Connie, with no need to filter or pretend to be something that I'm not. She accepts me

for the flawed person that I am and has never judged me or suggested I change anything about myself. The day we discovered that we both exclusively wear mittens, and never gloves, we questioned if we might be blood-related sisters switched at birth. Our friendship was locked in for life on that very day. Connie is the friend who will invite me along with her on her workout days, and then subsequently slow her normal workout routine to fit my pace, just because she enjoys my company. She is the friend who will cheer me on while doing the stepper: "You got this, just a few more, you're almost there!" When she walks into the room after not having seen me for several days or weeks, her face lights up and she wants to hear all about what's been going on with me. And she isn't pretending to care. She is truly interested and invested in our friendship. She is always kind and always fair. This type of human being is irreplaceable. Get yourself a Connie.

You need a girlfriend in your life who is in it for the long haul. Life is full of some really hard stuff and not everyone is cut out to hang with you through all the mud and the muck. If you have a girlfriend who has hung with you since the Tang and *Scooby Doo* years, that girl has earned her seniority. Do not ever let her go. I have a long-term-commitment friend and her name is Amie. We go back, like way back. Like big glasses, terrible perms, pedal pushers, and jelly shoes way back. Amie and I have been friends since we were nine years old. I met her on my first day in a new school (I'd had many first days in different schools, and they were never easy or fun). At the end of the day I was thrust into a mob of fourth-graders trying to fight their way to freedom. I was pretty sure I was supposed to catch a bus to get home but had gotten all turned around in this scary place and didn't quite know what I was supposed to do. I saw this girl with curly blonde hair and coke-bottle glasses that magnified her eyes about four times their normal size, and she had a huge infectious smile. I felt that she had the friendliest face of the bunch and was giving off the least "mean girl" vibe, so I walked up to her and asked, "Do you know where the bus is?" Without skipping a beat, she replied, "Uh...yeah... it's the big yellow thing outside." Okaaaay, so maybe she wasn't exactly

the nicest girl in the school, or maybe she just didn't care about making a good first impression. Her comment stung a little at first, because, hey, I was nine and terrified. But I quickly recovered with a witty and intelligent comeback that probably went something like, "Well, NO, DUH, tell me something that I don't know."

Not my best work.

It was clear that our sarcasm was going to be the making of a beautiful friendship that has lasted a lifetime. We quickly became inseparable, and through the years our tight friendship has waned and wavered. We no longer see each other in a classroom every day, sitting at a desk with a lid that lifts and stores our treasures and spelling tests. Sometimes we don't see each other for six months or a year. But we can pick up the phone and pick right back up where we left off, and if I called her out of the blue and said the words, "I need you," the girl would drop everything and she would be there. No hesitation, no questions asked. Get yourself an Amie.

You need a girlfriend in your life who is your "person." If you've ever watched *Grey's Anatomy* (and if you haven't ever watched it, then please direct me to whatever rock you have been living under, because I need an escape from reality and the entire world sometimes), then you know that Meredith has a *person* and her name is Christina. You need to have a relationship like these two in your life. You need a friend who isn't just your bestie… She is your touchstone. She is your safe place. She is your soft landing. My person is Pam. We met at work in the 911 Center. And from day one we clicked. Pam is the person who has tried to save me from myself when I'm about to do something especially stupid (on more than one occasion), but eventually lets me figure it out on my own, then comes alongside me afterward to pick up the pieces. She's the person I call when my world is falling apart and I cannot even speak words. As soon as she answers the phone and hears my shattered gasp on the other end of the line, her response is immediate: "What's wrong? Where are you? Stay there, I'm coming." Always. Without fail. Every single time. If I was curled up on the floor in broken desperation, she is the friend who would lay on the floor beside me until I could gather the strength to stand again.

When my grandmother passed away, it was sudden, and I was devastated. I was also nine months pregnant with my daughter and terrified of funeral homes and dead people. I was heartbroken like I had never been before, and I understood for the first time why they called it heartache, because I was experiencing for the first time in my life the actual physical pain in my chest at the loss of her. I was unprepared for handling a visitation or a funeral. I couldn't bear the thought of her being alone in the funeral home, lying in a casket in an empty room with somber lighting and low, dreary music playing in the background. I was determined to be at the funeral home all day long so she wouldn't be alone, and so any guests who stopped by to sign the visitation book would be greeted properly. My grandmother was a stickler for politeness and etiquette, and not greeting guests would have been utterly unacceptable. The problem was, I couldn't go into the room where her body was because I was petrified to see her like that, and I would have then been alone in a room with a dead body. *Nothankyouverymuch.* Pam came to the funeral home and sat outside the door of the visitation room with me *for hours.* She would ask me if I was ready to move a little closer to the doorway and we would inch the chairs over a bit. Then we would sit and visit. She would ask again later if I was ready to go just a little farther, maybe just over to the flowers. And we would move a little farther toward the room. Eventually she took me all the way into the room, keeping a tight hold of me and keeping herself between me and the casket. Shielding me with her body, so if it became too much to bear she could scoop me up. Because of her selflessness and the time that she devoted to being by my side that day, I was able to see my sweet grandmother and say goodbye to her.

Then things took a turn.

After Pam left and I was alone again in the funeral home, I decided I had braved it once and I could now go into the room alone and get a closer look. I got closer and closer and was hovering near the foot of the casket when I heard a loud bang on the other side of the wall that shook the entire casket, flowers, picture stand…everything. I screamed loud enough to call down heaven, and I'm pretty sure I peed a little, too. I

flew out of that room (okay, I fast waddled) and around the corner to the other side of the casket wall where I found a skinny teenage boy yanking a stuck vacuum from a very overcrowded storage closet. I did a cry/scream mash-up directly into his poor, innocent, future funeral director face and let him know how much his banging about had scared me and made me pee. I was pregnant, gigantic, sad, and hormonal. Please give me grace.

From that day forward Pam has been my human shield at nearly every funeral I have attended. She has been my beneficiary, my emergency contact, my roommate, my spare house key, my rock, my long car ride, and my go-to. She is my person. Get yourself a Pam.

ME: It's amazing to me how each of these women have been so impactful, and they all came into my life at different seasons.

GOD: You needed something different in each of those times.

ME: Clearly I needed a bus when Amie came along. *<rolls eyes>*

GOD: You needed someone who would always show you the way, whenever you needed her.

ME: Pam and I being friends is obviously all YOU. She likes the outdoors, camping, fishing, and dirt. She knows the names of tools and how to fix broken things. I like pink, sparkly stuff. Us being friends doesn't even make sense.

GOD: You compliment and need one another. She was your person long before you knew her.

ME: Connie and Kendra were a surprise. I thought I was past the age of making new lifelong friends, but now I can't imagine doing life without them.

GOD: This is an important new season of your life. The timing was just right.

ME: All these women are each so different and unique and yet it feels like they each fit into my life like a perfectly crafted puzzle piece.

GOD: I made you to have the love you have for each one of them.

ME: I definitely love them.

GOD: I made you to love *all* your sisters this way.

ME: Okay, just to clarify, by ALL you mean…?

GOD: All.

ME: Oh, come on! Why ya gotta make it about EVERYBODY!? You can't mess with my tribe like this! Love them ALL? How exactly am I supposed to do that?

GOD: Just like your heart yearns for the best for these four.

ME: But…

GOD: Just like you talk to me about them.

ME: But…

GOD: Just like you ask me to fix things that are hurting them.

ME: But…

GOD: Just like you pray to me and ask me to bless them.

ME: But…

GOD: Just like you worry for them, cheer for them, laugh with them. Just. Like. That.

ME: Yeah, yeah, I know you said, "Love others as yourself." I got that. I even have the tattoo, but not just everyone can be part of my *tribe*, for crying out loud. I mean, they won't all fit in!

GOD: They are all part of *mine*.

ME: *<sits slack-jawed, attempting to form a comeback>*

GOD: They are my daughters. I chose them. I chose you. You each belong to me. You are each part of the Kingdom. That is your tribe.

ME: You want each of us—your daughters—to know that we are all a part of something bigger. That we all belong.

GOD: Yes.

ME: Inclusive. No wearing pink on Wednesdays.

GOD: Right.

ME: Okay, point taken. We're all part of a bigger tribe, *your* tribe.

GOD: Yes. And I did give you these four of my girls on purpose.

ME: I knew it!

God knows we all have a deep desire to be known; that's how he made us. And he knows we have a need to be loved. He created us for

companionship, which is why he invented girlfriends. Don't get me wrong, relationships with our husbands are great, too, and God-ordained as well, but there is something special about the relationship between you and your girls. Proverbs 27:9 (*THE MESSAGE*) says that a sweet friendship refreshes the soul. That is a perfect description because these girls have breathed life into my soul at all different times of my life. They are irreplaceable to me, and I cannot imagine how differently my life would look if they hadn't been a part of it.

Get yourself some grapes, some salty squares, a squad, a team, or some soul sisters. These girls will bring you life and love, and will give you a free ab workout with the amount of laughter you will share. But as you're doing life with these girls, don't forget to look around you and notice that one girl who doesn't seem to be fitting in anywhere. She has something valuable to offer and she might not even know it, but you can show her. If you take the time to invite her in and show her some love, she will blossom. If each one of you reading this brought just *one* girl into your tribe, there would be a shift in how women treat one another. Maybe we would see women straightening each other's crowns rather than tearing them to shreds. We owe it to our daughters. They are forming young tribes of their own and they are watching ours.

HEY, GIRL

Hey, sister. I wish I could have been sitting across from you, sharing with you these stories and conversations with our Father face-to-face. I'm certain there would have been moments when we laughed so hard, we could barely breath, holding our sides and covering our mouths as we snorted, then falling over with even harder belly laughs. I'm also sure there would have been times when I would have seen your eyes fill with tears and maybe even a few would have escaped your lashes and slipped down your face before you could brush them away. I know I would have taken both your hands in mine and looked you directly in the eye as I proclaimed over you how powerful and fierce God's love for you is. I would have taken hold of each of your shoulders and given you a gentle shake, while telling you to stop carrying whatever it is the enemy has handed you that's weighing you down. You may have unknowingly taken what was handed to you, but you do not need to keep it. Set it down. Walk away from it. It doesn't belong to you.

Sister, if I was looking into your face, I would tell you that you are worth so much more than you realize. I would try my best to wordsmith my way through an explanation of just how much you are loved by our Heavenly Father. But I wouldn't do it justice, and let's be honest, the Big Guy tends to hijack my stories anyhow and says what he wants you to hear. So I thought it best to just step back and let our Father talk directly to you. This is his show anyway.

Love you, girl,

Until next time…

GOD: Daughter, I adore you. You don't know it, but every day you make me smile. I created you so I could love you. I want nothing more than to have a relationship with you. I want to share every part of your life with you. I delight in you. Not the pretend version of you. Not the version of you that you show to other people. Just you. Just as I made you. I don't expect anything else from you. I can handle all the parts of you. I can handle it if you are mad…even at me. I can handle it if you are sad…even if you believe I allowed it. I love it when you're joyful, but I can handle it when you're hateful, too. Your emotions don't scare me. I created them. And I have felt all of them, too. Just be you. But do it next to me.

You are never alone. No matter what, I won't leave you. Nothing and no one can change that. The light I've placed inside of you can never be extinguished. You can't do it. No one can do it *to* you. I AM the light.

I have so much I want to give you. I have such big plans for you. But I need you to trust me. My plans are big, and they take time. The part I have for you is complex and I made you uniquely designed to accomplish it. Doing what I need you to do will make you uncomfortable. It will stretch you beyond what you think you can do. That's how I'll show you it's me doing it. Don't worry. I will help you. I won't harm you. But fear will try to convince you that what I ask you to do will hurt you. Fear is a liar. My love is not dependent upon you completing the assignment I made you for. You don't have to do it. You can do nothing. You can stay comfortably right where you are, and I will still be madly in love with you. And I will continue to care for you and to bless you. Nothing will ever change how I feel about you. My love is secure and unending. But—if you'll trust me—I have so much more than comfort to give you.

There is nothing that can hold you back from what I have planned for you. You are worth more to me than all the stars in the sky. Everything you have experienced has been preparing you for what I created you to do. I chose you. And nothing will make me change my mind. There is

nothing you can do. I don't care about the mistake you made. When you asked me for my forgiveness, I gave it to you. I never asked you to continue carrying around the weight of it. Put it down. I've already forgotten it. I know that you have suffered. I was there. Stop carrying the pain. I am going to use it. But I need you to set it down and let me have it.

That thing I've called you to do, I placed it in your heart. I put the desire in there, so you would always feel it and carry it with you. I thought it up a long time ago, before you were born. I created you and placed it inside of you when I knitted you together. I introduced the idea to you subtly when you were small. I planted the seed inside of you and put people and situations in your path to water the seed and make it grow within you. You stopped watering it for a while, but it's still there. I can give you living water that will make the seed of your purpose bloom and explode with color. Will you trust me?

This thing in your heart, it may seem impossible. It isn't. Nothing is impossible with me. It's okay if you have questions. Ask me. I will give you all the answers that you need to take the next step. I won't show you the entire plan. It's too much. You may not understand the bends and curves in the road that I'm taking you down, but I promise it's worth what's waiting at the end, and someday it will all make sense. In the meantime I will show you each step to take next. Just ask. It's okay if you fall. I'll help you back up. It's okay if you take a detour down a different way. I'll walk with you. When you're ready to get back on the path, I'll show you the way out to *my* road. We aren't in a hurry. I'll wait for you to be ready. I'm excited to get to the end and give you all that I have planned for you, but we don't have to go that far if you don't want to. I will take you as far as you're willing to walk with me. I just want to be with you.

You never have to doubt my love for you. Nothing else will ever fill the empty places you have. I designed you to crave me and need me. I alone can make you whole. Another person or thing cannot do this for you. That is not how you were made. When you feel as though you are searching and reaching for…something, it's me. I'm here. Come and sit

with me and talk to me. I can fulfill your every need. Come to me. You will lack nothing. I AM the beginning and the end.

You are perfect. You are not a mistake or an accident. You are not flawed, broken, or unusable. I created you exactly as I intended. I do not make mistakes.

I chose you. You are mine. You are a part of my family. You belong. You are my daughter. You are royalty. You are worth more than gold. You are created with purpose. You are destined and assigned. You are marked, set apart, and holy.

I can't wait to talk to you again.

Never ever forget that I will always love you...no matter what.

A Letter to Our Daughters

I penned these words to my beautiful daughter Cassidy to speak over her when she participated in her rite of passage ceremony at our church. She was acknowledging before God and our congregation that she was ready to step over the threshold of childhood into adulthood and proclaiming that she was choosing to follow Christ into this next season of her life.

Watching this young woman, flesh of my flesh, blossom in her faith was the most exquisite and heart-gripping moment I have ever experienced, even surpassing the moment this same fair-skinned, dark-haired infant was placed into my arms at birth.

I want you to read these words twice. First, I want you to read them spoken over you personally and take in the enormity and the absolute certainty of who God says you are. Once you fully grasp who you are in Christ, you can place that blessing onto your own daughters. Next, read these words aloud to your daughter. Speak over her the powerful love of her Heavenly Father, then sit back and watch his reckless love take hold of her.

_____, *you are my daughter, chosen and marked by God's love, the pride of my life.*

I prayed to God for you. God heard my heart, just as he hears yours, and he gave me abundantly more than I asked for. When you were babies, I dedicated you and your brothers to God, I gave him control over the most precious things I owned, and you are dedicated to him for life (1 Samuel 1:27–28, THE MESSAGE).

This means you are royalty. He has placed a crown upon your head, and you cannot do anything to lose your place as a daughter of the King. You are my daughter here on earth, but you belong to the Father. I love you more than anything in this world, but it isn't a fraction of how much God loves you. The King of the heavens is wild for you (Psalm 45:10–11, THE MESSAGE).

God knows that you belong to him (2 Timothy 2:19, THE MESSAGE), and he will never ever forget you. People will disappoint you in life, let you down, and hurt you. People will be people. You have to understand that and forgive them. But God will never let you down or leave you—he has engraved you on the palms of his hands (Isaiah 49:15–16, NIV) long before you were born. You are more precious to him than diamonds or rubies (Proverbs 31:10); you are a stunning crown in his hand, a great treasure that he holds high and will always take care of (Isaiah 62:3, THE MESSAGE).

God already had you in mind well before I asked for you. He designed you exactly as he needed you to be to fulfill the purpose and assignment that he has for you. You are beautifully and wonderfully made (Psalm 139:13–16); you are complex, quirky, and multifaceted. Every single neuron in your brain fires exactly as it was intended. God does NOT make mistakes. You are not broken— you are blessed.

You will discover gifts and talents that shape you for your purpose. I asked God to make you intelligent and discerning in knowing him

personally, to keep your eyes focused and clear, so that you can see exactly what it is he is calling you to do (Ephesians 1:15–19, THE MESSAGE). Each of us is given our own gifts (Ephesians 4:7, THE MESSAGE), and when you find that gifting and combine it with your life experiences you will do GREAT things for the Kingdom, and I will be there every step of the way, cheering you on. You can't even imagine all the things that God can do through you. He can do anything; his plans for you are bigger than your wildest dreams (Ephesians 3:20–21, THE MESSAGE).

All you have to do is love God and talk to him always. He won't leave you trying to figure things out on your own. All you have to do is ask, and he will show you where to go. He will give you a full life in the emptiest of places (Isaiah 58:11, THE MESSAGE). You will be tempted over and over to fill your voids or empty places with people, relationships, or things. These will only be a temporary fix. The only thing that truly lasts and makes you feel complete and at peace is Jesus, knowing him, knowing who he says you are, and believing it. You will be a blessed woman, if you just believe what God says, and believe every word will come true (Luke 1:45, THE MESSAGE).

The whole point of life is to simply love. Love not out of self-interest or a sense of obligation or fake churchy faith, but a life open to God and in a relationship every day with him (1 Timothy 1:5, THE MESSAGE). God simply wants you to get in there and do life with humility, not primping before a mirror or chasing the latest fashions, but doing something beautiful for God, and becoming beautiful doing it (1 Timothy 2:8–10, THE MESSAGE). God doesn't love you to get something out of you, but to give everything of himself to you. Go out into the world and love like that (Ephesians 5:2, THE MESSAGE).

And never forget that you are always loved.

"For even if the mountains walk away and the hills fall to pieces, my love won't walk away from you, my covenant commitment of peace won't fall apart. The God who has compassion on you says so" (Isaiah 54:10, THE MESSAGE).

CPSIA information can be obtained
at www.ICGtesting.com
Printed in the USA
LVHW081211211219
641341LV00008B/25/P